Shark

Animal
Series editor: Jonathan Burt

Already published

Shark

Dean Crawford

REAKTION BOOKS

Published by
REAKTION BOOKS LTD
33 Great Sutton Street
London EC1V 0DX, UK
www.reaktionbooks.co.uk

First published 2008
Copyright © Dean Crawford 2008

Printed and bound in China

British Library Cataloguing in Publication Data
Crawford, Dean
 Shark. – (Animal)
 1. Sharks 2. Animals and civilization
 I. Title
 597.3

 ISBN-13: 978 1 86189 325 3

Contents

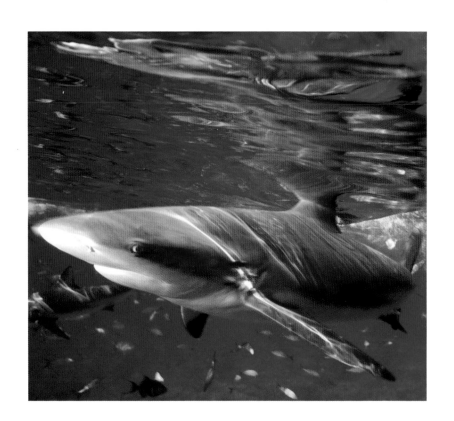

Introduction

Sharks inspire terror out of all proportion to their actual threat. We may wonder what they did to earn such special attention. Did they chomp down on our prehistoric ancestors often enough to create an evolutionary memory, a kind of monster profile in the lower cortices of our brains? Or are we exercising that special combination of loathing and fascination that humans reserve for a predator at least as well designed and widely feared in its watery realm as we are on the land? Sharks are so *other* that they don't even have bones, but cartilage. Many shark species are ovophageous, meaning that they eat their siblings in the womb. When sharks feed, they shutter or roll back their eyes, giving them – to our eyes – an ecstatic expression. Their wriggling white bellies look obscene.

Whether from terror or excitement or some combination of the two, we all thrill to the sight of a dorsal fin cutting through the water. And yet, majestic as they may seem when glimpsed in the ocean, sharks are a challenge to love. Unlike wise old whales with their mournful tunes, or baby harp seals with their pleading eyes, some sharks are genuine monsters. Great white sharks weigh between one and two tonnes, more than an average car. Never mind that vehicles slaughter tens of thousands of us every year while sharks on average kill fewer than twenty worldwide. Sharks just look like thugs with those hunting-around

eyes. Seen from the front, white sharks appear to be *grinning*. Then they turn to look at you with their flat, black, fathomless, alien eyes. Sharks' behavioural habits are foreign to our tender mammalian sensibilities. All sharks are cannibals. Female sharks come equipped with a special mechanism to repress their hunger during and immediately after childbirth – otherwise they would eat their own young. The white shark's favourite food is not family members, but the baby elephant seal, too small to defend itself with tusks or claws, too naive to know to avoid the sharks lurking along the bottom just off the beaches where elephant seals breed and give birth and the young must put to sea to survive.

What is it about sharks, especially the larger ones, that evokes the juvenile in some of us, the testosterone in others and awe in still others? Many people harbour a fear of sharks. Some of us have nightmares. Some of us are nervous even when swimming in a freshwater lake or pond. It is easy to see why normally courageous people might choose to sit on the beach rather than swim, why otherwise temperate people might take up arms against what they perceive to be a sea of troublemakers, or why awe might manifest itself as idolatry. We might say that these people go with their feelings, following their fears into avoidance, pugnaciousness or reverence. These categories of response are not mutually exclusive, however: many of us experience two out of three. We fear sharks, so we take to our boats to catch and kill them. Or we thrill to the power and beauty of sharks all the more because we fear them.

Peter Gimbel, the banker turned documentary filmmaker who organized the great shark expedition that became the film *Blue Water White Death*, admits to having a recurrent nightmare about sharks:

This nightmare, which also popped up occasionally as an inner vision by day, always followed the same pattern. I was swimming among the great blues in the middle ground. Abruptly, they disappeared beyond my perimeter of vision leaving only the gray-blue blankness of the open ocean. I spun round and round, trying to look in all directions at once, sensing that something enormous was just out of sight. A form appeared, huge beyond imagining. It came rapidly toward me and materialized as the great white shark, the man-eater. It bore straight in with overwhelming speed, and as the jaws opened to swallow me I would awaken and begin thinking of what desperate measures to take if the nightmare – or daymare – came true.[1]

Detailed as Gimbel's nightmare may be, it's one shared by many of us with a shark fascination: the aloneness in a vast ocean, the

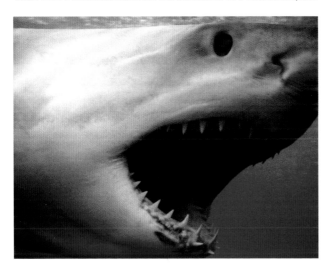

The iconic Great White shark (*Carcharodon carcharias*), South Australia.

awareness of an approaching shark, the pressure wave, the overwhelming force, the consideration after waking in a cold sweat of whether it would be better to lose consciousness and drown or to expire more slowly while waiting for the shark to return for another bite.

Anyone who has seen Gimbel's classic shark documentary (or read Peter Matthiessen's narrative about the voyage, *Blue Meridian: The Search for the Great White Shark*) will remember the scenes of the oceanic whitetips feeding on the carcass of a whale. From the safety of the boat we see their dark shapes and wide pectorals beneath the surface, their distinctively rounded dorsal fins cleaving through the waves. These are the most feared open-ocean sharks, probably the greatest killers of all (many of their victims – shipwrecked sailors and survivors of air disasters – have gone unrecorded). Divers work from cages in the water filming the sharks – dozens, maybe hundreds of them – as they approach the whale, latch on, wriggle loose a huge bite and glide away, open-mawed, to swallow. In a kind of slow motion the sharks thrash and nip at each other. When the divers take a break to change tanks they're grinning, aglow with excitement at what they're catching on film. They complete each other's sentences. Then Gimbel, a boyish gleam in his eye, proposes that he and the other divers leave the cages and swim freely among the feeding sharks. Ron Taylor, one of two Australians on the expedition, assents with a casual 'sure, mate'; he's swum with huge sharks as recently as the night before. But Stan Waterman, an expert diver and adventurer, visibly stiffens at Gimbel's suggestion. These sharks are 3.5 metres long; around the carcass the water is cloudy with whale blood and blubber. Yet Waterman goes along. Gimbel's theory, which proves correct, is that sharks have no more than a passing interest in divers and can be easily fended off when one of their

favourite foods, smelly dead whale, is nearby. However, in 1969, when Gimbel's 1969 documentary was filmed, the 'feeding frenzy' was still considered a scientific fact. Leaving their cages to mingle among the whitetips was a brilliant act of possible madness, inspired not only by a desire to get the best footage for the film but also by the divers' willingness to risk their necks (literally), to take a swim on the wild side.

A shark's eyes reflect neither light nor emotion, not even fear or menace. When the shark bites, its eyes either roll back or are shuttered by a nictitating membrane to protect them from the desperate scratches of its prey. It opens its mouth so wide that folds form down its white underside, and undulate as the shark wriggles, carving out a chunk of meat. As the shark pulls away, its eye sockets are white, like a zombie in a narcotic state.

Some people wonder why we should care if these monsters become extinct. Just because they're old enough to have seen the dinosaurs come and go? Yes. Sharks' longevity on the planet is reason enough for their preservation, particularly when we consider that the only threat to their future existence is us. Unlike other species that have become extinct because of climate change

Close-up of nictating membrane over eye of tiger shark (*Galeocerdo cuvieri*) Great Barrier Reef.

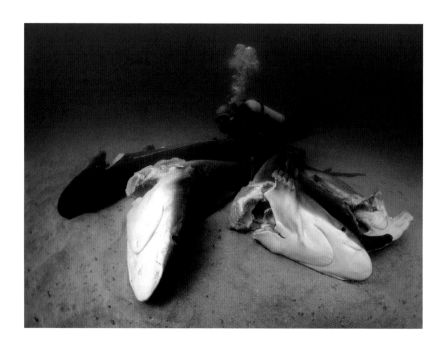

Diver observing dead sharks on sea floor, finned alive and thrown overboard to drown, caught on longline, Cocos Island, Costa Rica, Pacific Ocean.

or a meteor crashing into the Yucatan, sharks are threatened strictly because of human disregard: industrial-fishing operations that round up everything; by-catch, meaning inadvertent killing on a mass scale; and shark-finning – the harvesting of fins for an expensive soup that represents prestige for hundreds of millions of people and results in the killing of tens of millions of sharks every year, an unsustainable slaughter. Nature has evolved several hundred distinct species of shark not merely out of whimsy. Sharks play an important role in the food chain and in the balance of sea life. While we can try to imagine the spiritual loss to future generations deprived of any glimpses of these great predators, the emblems of wilderness on earth, who can predict the environmental consequences if all our oceans are purged of sharks?

When they come to write the history of the shark's demise –
assuming we haven't mustered the imagination and the will to
save them – our descendants will focus on four important dates,
all of them remarkably recent relative to the many millions of
years that sharks have been swimming on earth. In 1916, when
true horror was raging in France, the American media redirected
public hysteria to a series of shark attacks that took the lives of
four young men, and thereby created the myth of the malevo-
lent rogue shark that preys on human flesh. In 1945 the USS
Indianapolis sank (after delivering the atomic bomb) and,
because of the inept bureaucracy of the US Navy, 900 survivors
were left for five days in water frequented by the oceans' greatest
scavengers, with predictably horrifying results. In 1975 one of
the world's greatest movie directors made a horror movie, using
not the usual Dracula or werewolf myths but a newer (yet per-
haps more basic) terror, elevating the shark's mythical status to
that of a totem. As Orson Welles intones on the original trailer
to *Jaws*:

> There is a creature alive today that has survived millions
> of years of evolution without change, without passion,
> and without logic. It lives to kill; a mindless, eating
> machine. It will attack and devour anything. It is as if
> God created the devil and gave him . . . jaws.

But perhaps the most significant date, at least so far, is 1987,
when the Chinese authorities determined that shark-fin soup
was not so bourgeois or politically incorrect after all. Previously
the Central Committee had described it as a throwback to the
imperial era. Since 1987, however, when the authorities lifted
the ban on this extravagant dish, worldwide demand for shark
fins has soared.

Where is ideology when we need it? The list of what would be lost if sharks disappear begins with food for artisanal fishermen in the developing world who are already losing catches to modern technology. Shark meat is a crucial source of protein for many poor fishing communities in Africa, India and South America – just the kind of people that Maoism is committed to protect. These small, sustainable shark fisheries are threatened by the large, industrial operators, who often violate local regulations and customs while devastating coastal fish populations.

Normally, sharks – the scavengers of the sea – clean up the carcasses of other sharks, old and sick fish, whales and other weakened sea mammals. Such disposal services are part of the shark's function. Like wolves, lions, tigers and bears, sharks also fulfil an evolutionary function, eliminating the weaker specimens and thereby strengthening every school of fish or herd they prey on. What if these predators went on a permanent – that is, eternal – strike? Sharks hold other fish populations in check. For instance, according to a 2005 study by the National Academy of Science, Caribbean reef sharks eat the carnivorous fish that eat parrotfish, which graze on reef vegetation including algae.[2] The loss of reef sharks would therefore have a domino effect, resulting in severe damage to the reef itself. And this pattern would apply to food chains not only on reefs but throughout the oceans. From a selfishly human perspective, sharks are our only living link to the Jurassic era, a time when dinosaurs walked the earth and swam the oceans, when nature was experimenting wildly with living forms. Indeed, sharks are among the few creatures that embody wilderness. They demonstrate the existence of wilderness just by being there.

In *Monster of God*, David Quammen's fascinating reflection on our relationship with animals that are capable of eating us, he writes:

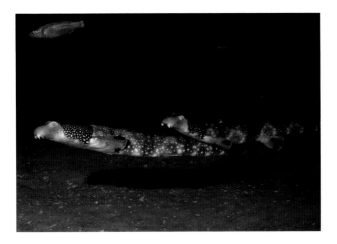

Necklace carpet sharks or varied carpet sharks (*Parascyllium variolatum*), Victoria, Australia.

Have crocodiles and sharks committed ugly, horrific acts of homicide and anthropophagy? Yes, and by doing so they've offered us a certain perspective. While we humans may be the most reflective members of the natural world, we're not . . . its divinely appointed proprietors. Nor are we the culmination of evolution . . . Throughout the course of the human story, one reminder of our earthly status has been that, at some times, in some landscapes, we have served as an intermediate link in the food chain. I'm not talking now about that scriptural food chain of power and glory, which the Lord so firmly impressed upon Job. I mean the literal food chain – who eats whom.[3]

What many of us tend to overlook – or not even realize – is that sharks are beautiful. Blue sharks are, in fact, sapphire. Makos are iridescent. Cat-eyed Caribbean reef sharks approach like cats, sinuously. Even white sharks, the supposed monsters, the

big-bellied brutes among the *lamniformes*, are commandingly beautiful, majestic, when seen in the wild. Few people get to see white sharks that are still alive. They are notoriously difficult to keep in captivity and the aquaria that have tried have all failed, their sharks dying or being returned to the ocean. The Monterey Aquarium came the closest to success, keeping one young shark on display in its main tank for five months, until she began ignoring her prepared meals of dead fish, feasting instead on the other sharks in the tank. Crowds flocked to the aquarium, thrilled to see not only her slightly open jaws but her demeanour, her natural awareness of her supremacy as the largest, toothiest fish in the tank – or the sea.

I was lucky enough to see white sharks at the Farallon Islands, just 27 miles from San Francisco and within the city limits. I was researching an article about cage diving and I'd always been curious about the place. The Farallons are just piles of grey rocks, entirely devoid of vegetation. To the Miwok Indians they were the place of the dead, and they do look forbidding, jutting up at the horizon. Against the heavy swells it can take four hours to get out there, and it's *cold* – cold water, chill wind, and it feels eerie around the rocks because of the knowledge of what's down there, patrolling the bottom, looking for a silhouette on the surface that matches the ideal image in its brain: *prey*. From September to December, the Farallon Islands are home to multitudes of white sharks. Situated at the edge of the continental shelf, the islands enjoy one of the richest marine environments on earth, host to the whole of the food chain, from algae that bloom in the upwells to krill, all manner of shellfish, albacore, halibut, as well as porpoise, four species of whale, Stellar sea lions and the even more calorific elephant seals. Because the chubby juvenile seals flock there every autumn, so do the sharks. Only one commercial diver works at

the Farallons; he's given up trying to keep a partner. There is also a small group of scientists in residence during part of the year, monitoring the shark attacks on seals and sea lions, setting GPS tags and filming when they can. I watched Ron Elliott, the fearless diver, harvesting sea urchins while avoiding sharks. Then I spent a precious hour in a small boat with shark researchers Scot Anderson and Peter Pyle.

Scot and Peter have been researching for so long at the Farallons that they know the sharks by their scars and scratches and they've given them names. They picked me up in their Boston whaler, at 4.5 metres slightly shorter than the average white shark. Because of an experiment they were conducting, I was able to see a shark jump. It was an adolescent shark, about 3.5 metres long and weighing less than 900 kg, and it actually had four colours, none of them quite black or white: charcoal on top, ivory on the bottom, with an indigo band fading to azure on its flanks. Before returning me to Ron's boat, the scientists gave me a short tour around the island, just a half circle, during which we noticed some heavy gull activity over one spot in the water. Peter cut the motor and let us coast in. We could smell the oil in the air. 'A mid-water kill,' he said. 'No carcass.' Then we looked below the boat and saw four sharks, each as wide as the boat and a little longer, criss-crossing beneath us like airliners under their own traffic control. They brushed the hull. They seemed to sniff the outboard motor. They glided, never rushed.

Later, on the cage dive trip, I saw a breaching shark. It was immense and got our adrenalin flowing, also inspiring a great many *Jaws* jokes. For the next six hours we took turns dangling in the cage. A shark glided by, like a submarine with a swaying tail. Then it vanished and we settled down to enjoy the more delicate life forms. The jellyfish came in all diaphanous shapes

and sizes, from clear coin-sized polyps and bells to giant lamp-shades parading by with their naked innards exposed beneath an ectoderm of negligee material. Some looked like cucumbers, both squat and extended; others were rectangles with a pair of eyes at one end like curious Paul Klee creatures or legless squid. We saw shrimp in every conceivable contortion, some resembling bits of bead necklace or with vertebrae apparently untethered from the rest of their skeletons. In the afternoon, as a red tide of krill swept in and slowly engulfed us, my cage-mate and I constantly prodded and tugged at one another, pointing out the minute amber creatures or the small flounder flapping through the bars. Memories of submarine shapes and long scythe-like tails faded into the gloom as we focused on the smallest of visible small fry, the constantly changing mix of life and life-sustaining nutrients floating by.

By the time this book is published it will probably be out of date. I hope it is, because that will mean there have been new discoveries about sharks and newly discovered species of sharks. There are currently 454 known species of shark. A new one was discovered in September 2006 in Indonesian waters, an epaulette shark that walks on its fins. It was found in the so-called 'Coral Triangle' along with eight new species of shrimp, 22 previously unknown kinds of fish and twenty new species of reef-building hard corals.[4] At least a million species, perhaps as many as 9 million, live on or near coral reefs – our underwater rainforests, jungles and a hotbed of new life.[5] How Darwin would have thrilled if he'd been able to encounter underwater, or even study above the surface, the enormous array of marine creatures that we're pulling up both from the depths and the shallows of our seas. The clever cookie-cutter; the viper dogfish with its fangs and expression of cartoon glee; the hammer-heads scouring the sand with their metal detectors mounted

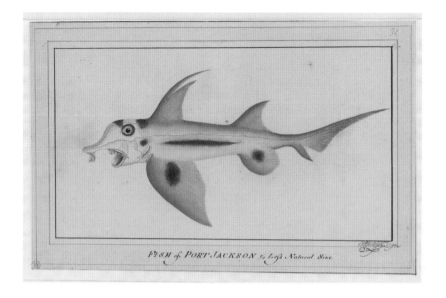

FISH of PORT JACKSON ½ Less Natural Size

on their heads; the catsharks with their array of names – hoary catshark, flaccid catshark, spatula-snout catshark, Pinocchio catshark, fat catshark; the blackbelly lantern shark with its bioluminescent organs creating just enough light to simulate the glow from the surface of the sea. What evolutionary gene could devise such a clever camouflage? It's true that our oceans are threatened by other catastrophes besides overfishing. But one of the saddest things, the most unnatural omission, would be loss of the ancient creatures, including the shark, from this cavalcade of life.

George Raper, Raper Drawing no. 33, 'Fish of Port Jackson' (Elephant Fish, *Callorhinchus milii*), 1790.

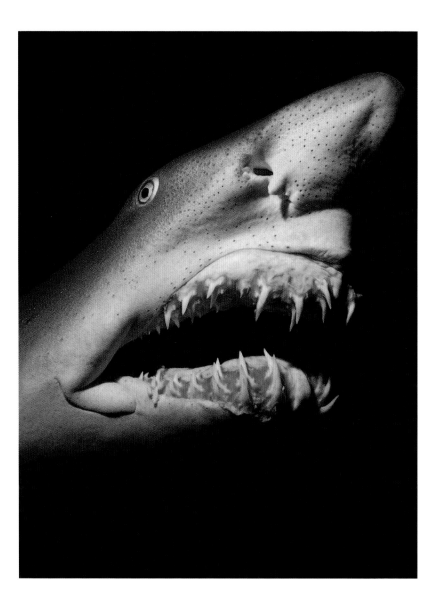

1 A Timeless Design

Compared to a time-tested design such as the shark, *Homo sapiens* is a recent prototype. Geneticists estimate the age of our own subspecies at a mere 200,000 years, whereas Mother Nature has been mass-producing sharks since well before the Jurassic age, more than 130 million years ago. Fossils of the common six-gill shark, of the order *Hexanchiformes*, have been dated to the Permian period, more than 225 million years ago. Canadian palaeontologists recently discovered in New Brunswick a full fossil of a 409-million-year-old *Diliodus problematicus*.[1] Sharks predate the dinosaurs, not to mention mammoths, mastodons, sabretooths and thousands of other species that nature discontinued. Humans may be one of the most numerous species on earth, our numbers exceeded only by certain insects and bacteria, but we're not diversified. For all our heights and hues, we are only one species. All our eggs are in one basket, named *Homo sapiens*, which leaves us completely vulnerable to a universal agent, a disease or toxin or some other metaphorical dropping of the basket.

Sharks, on the other hand, enjoy a bounteous diversity. Beside the four truly dangerous sharks, the great whites, tiger sharks, bull sharks and oceanic whitetips – those most often conjured in hysterical news stories, sensational films and our nightmares – there exist such unlikely-looking creatures as the

Sand tiger shark (*Carcharias taurus*) at night off North Carolina.

Shark ray, better called bowmouth guitarfish (*Rhina anclyostoma*), Queensland, Australia.

goblin shark (*Mitsukurina owstoni*) which sports a pike above its mouth; the thresher sharks (phylum *Alopias*), whose scythe-like tails account for 50 per cent of their total length; the megamouth shark (*Megachasma pelagios*), discovered in 1976 when one attempted to eat the sea anchor of a warship; the sawfish shark (of which there exist nine distinct species), whose snout looks like a chainsaw; the bonnet and hammerhead sharks which look like cartoons of a shark whose head has been flattened in a vice; and the ingenious little cookie-cutter shark (*Isistius brasiliensis*) which dashes in, latches on to a much larger prey, and corkscrews out a circular bite. When it comes to the shark, nature is nothing if not inventive. The swell shark (*Cephaloscyllium ventriosum*) inflates itself to several times its normal size by sucking in water, both as a defence and as a way to expand its mouth, which it then holds open like a Venus flytrap, waiting for an unsuspecting fish to swim in. The bull shark

The swell shark (*Cephalosyllium ventriosum*) swallows water to inflate itself to a larger size, not only to compensate for its harmless appearance, but also to wedge itself in crevices.

(*Carcharhinas leucas*), a less amusing species, can adapt to either fresh or salt water and has been caught as far up the Mississippi as Illinois, 1,750 miles from the sea. Even more unexpectedly, in May 2007 a bull shark was caught in the Neva River, at St Petersburg in Russia, which is not only fresh water but thousands of miles from their nearest warm-water habitat.

Known by many local names, including Lake Nicaragua shark, Van Rooyen's shark and Zambezi shark, the bull shark is often considered to be the most aggressive species. (In fact, it may contain the highest percentage of the aggression-related hormone, testosterone, of any animal.) Bull sharks prefer the murky and muddy water close to shore. They haunt the mouths of rivers throughout Indonesia, the Caribbean Basin, the Gulf of Mexico and the Indian Ocean. They follow the canals into residential areas of eastern Australia and Florida. They infest the Amazon, swimming upstream more than 2,300 miles. Many

Fishy business: a bull shark caught near St Petersburg, Russia.

scientists have speculated that the infamous Matawan Shark of 1916, model for the 'rogue shark' in *Jaws*, was in fact two or three sharks, at least one of which must have been a bull since it travelled two miles up New Jersey's brackish Matawan Creek to a muddy freshwater pool, where it killed two swimmers and maimed a third. These sharks can be amazingly tenacious, sometimes refusing to relinquish their victims even after being dragged on to the beach. In the case of the attack on Jessie Arbogast, who was bitten repeatedly in 60 centimetres of water while fishing off a sandbar on the Gulf Coast of Florida in 2001, both boy and bull shark had to be pulled ashore together. Jessie was bleeding profusely with the two-metre shark clamped to his leg. Only when the shark had been shot with a rifle could the animal's jaws be prised open, and rescuers were able to recover Jessie's severed arm from its throat.

Chuck Anderson, a high-school athletic director from Alabama, was training for a triathlon when he was attacked just offshore by a 2.5-metre bull shark. The shark bit him on the leg, the hand, the stomach and just kept coming back. Finally it held on, dragging him across the bottom towards the beach. Anderson dragged himself out of the water with the shark clamped down on his arm. Only by yanking, 'degloving' his forearm of skin and muscle and losing his hand, was Anderson able to free himself.[2]

Appalling as such incidents may be, the bull shark also represents an amazing adaptive achievement, being able to adjust the urea content in its blood to maintain a balance in the osmosis process within its kidneys. Other, very isolated freshwater sharks exist – the Bizant River shark (*Glyphis* sp. A) and the Northern River shark (*Glyphis* sp. B) that live in freshwater rivers in northern Australia – and other fish species such as eels and salmon pass from fresh to salt water at different stages of their life cycles. But what makes the bull shark so singular is its ability to make the biological switch *routinely*. Bull sharks routinely swim from the Pacific Ocean up the San Juan River to Lake

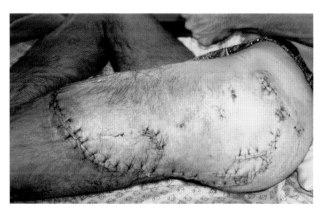

Injuries to Andrew Carter, survivor of a 1995 shark attack. Hideous as such injuries certainly are, they are no more shocking than the far more common, far less frequently photographed injuries from car accidents.

Nicaragua, where they attack people, pets and livestock. Once believed to be a separate, landlocked species, the Lake Nicaragua shark has recently been observed commuting up and down the seventeen-mile river, negotiating the rapids along the way.

In the south-eastern US and along the Gulf Coast, bull sharks are sometimes referred to as 'gentlemen in grey suits'. Unremarkable in colour with short, blunt snouts, they are typical *Carcharhinid* sharks, usually distinguished by their stockiness, their small eyes and their lack of such beauty marks as black fin tips. So what is there to recommend them? The easy answer is their use to us. Any living creature with such a highly responsive kidney function is a marvel of biological engineering, worth

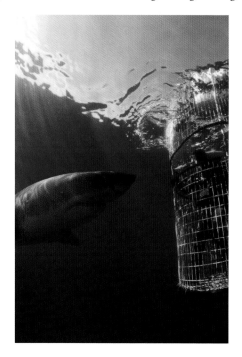

Scuba diver in South African style shark cage, viewing Great White sharks, Dyer Island, South Africa.

having if only for the possibility of later imitation. Beyond the selfish, anthropocentric issue of the bull shark's possible utility to us, however, lies the question of its place within a larger system. In the bull shark, nature has created an elegant adaptive design for which the future may hold a purpose beyond anything we can currently imagine.

The dominant ocean predator, at least among fishes, is *Carcharodon carcharias* – the great white shark. As long as 6.7 metres and weighing more than 180 kg, white sharks are simply huge, often a metre and a half wide at the beam. When encountered underwater in poor visibility, the shark's tail and head are not visible at the same time. Monstrous as white sharks may appear, however, they're only scale models of their ancestors, *Carcharodon megalodon*, which ruled the seas during the middle and late Cenozoic period, roughly 50 million years ago. Megalodons, meaning 'great tooth', have been estimated from their fossilized feet and jaws to have been sixteen metres in length and to have tipped the scales at eighteen tonnes, about ten times the weight of great white sharks. They are believed to have survived

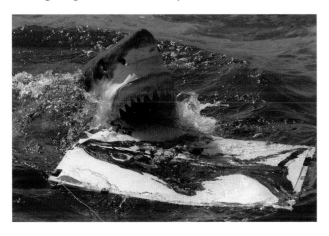

Great White shark at Dyer Island off Cape Town with Olly and Suzi's painting *Shark Bite*, 1997.

into the latest Pleistocene or even our Holocene period, which is the last 10,000 years, meaning that prehistoric humans may have seen megalodons.[3] We can imagine how the terror of sighting a two-metre dorsal fin might send shock waves down through our hereditary DNA. The cause of the megalodon's extinction is unknown. Beside the obvious predatory benefits of being the biggest, fiercest fish in the sea, mass helps to conserve heat, making it easier for the largest ocean creatures to maintain their body temperatures above the level of the surrounding water and thereby enjoy the advantages of quicker muscular reactions. There is no evidence to suggest a lack of food for megalodons. Their preferred meal was whales, of which there were no known insufficiencies until the twentieth century. Their disappearance is thus a mystery, one reason why sensationalist writers and filmmakers imagine them still living in the Mariana Trench, near Guam.

White sharks also enjoy feeding on whales, but only the dead or infirm ones who can't defend themselves. Without apparent regard for their cholesterol levels, they eat great chunks of whale blubber, first below the water line, then above, hurling themselves out of the water to seize and tear out a ten-kg mouthful before flopping back in. Fat tissue can be metabolized into heat much faster than muscle, and the lamnids or mackerel sharks (makos, porbeagles, salmon sharks and great whites) maintain body temperatures at least three to five degrees Celsius above the temperature of the water. Warmer muscle and nerve cells react faster to stimuli, adding to the advantages of surprise. The white shark's typical modus operandi is to cruise the bottom, nine to fifteen metres below the surface, scanning for the silhouette of a seal or sea lion, then hurtling upwards in an open-maw rush to deliver a disabling initial wound. White sharks don't look for a fair fight. They prefer to lurk nearby while their victims expire, then feed at leisure.

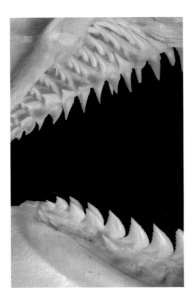

Sharks' teeth are designed to work in tandem, lowers for holding and uppers for cutting.

The great white shark is admirably adapted to its tasks of hunting, killing and feeding. Its jaws are famously immense and powerful, exerting almost a tonne of pressure per square centimetre and housing up to four full rows of granite-hard teeth. (Sharks' teeth, set in gum tissue rather than a jaw bone, rarely fracture, but they do break off, so it's shrewd of nature to keep multiple rows in reserve.) While the white shark's narrower lower teeth spike the prey and hold it in place, its triangular upper teeth with their sharp serrations can saw through both flesh and bone rapidly and efficiently. White sharks are also able to project their teeth by pulling back the fleshy tissue around their mouths – think of this fleshy part as their lips – and lifting their long snouts. This technique is particularly useful when biting into larger prey, the flanks of whales or the midsections of massive elephant seals. Sharks also have the sensitivity to

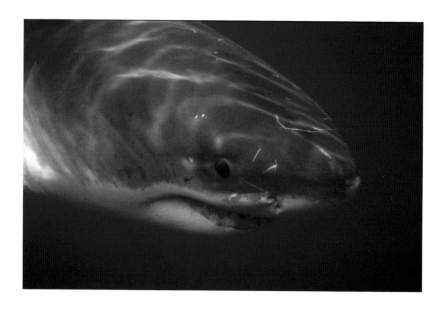

evaluate the consistency and the taste of the meat in their
mouths. First, their gums sense degrees of softness and hard-
ness. Second, their tongues can taste not only blood but also fat.
White sharks will often spit out their prey if the taste, firmness,
or mouth-feel suggests that killing and consuming it are not
worth the effort. The good news is that humans, apparently,
are too lean and bony to be desirable. The bad news is that the
initial, exploratory bite of a white shark can be fatal.

If we can ignore their rare but devastating attacks upon us,
we see that great white sharks are beautifully engineered from
tip to tail. Their snouts are conical, like aeroplanes, and for sim-
ilar design reasons. Their tails are enormous, with equal-sized
lobes (like those of tuna), also designed for bursts of speed.
White sharks may not be zippy by the standards of makos or
dolphins, but fifteen mph is more than sufficient for an ambush.

Their pointed nose cones contain nostrils, powerful olfactory sense organs capable of detecting minute amounts of blood in the water, perhaps as little as one part per 10 billion.[4] Also located at the tip of the white shark's snout are electrical sensors, jelly-filled pores that look like black stubble. These sensors, called ampullae of Lorenzini, detect the electrical energy created by movements as small as the flutter of a fin or a heartbeat. Awkward or erratic movements such as the thrashing of an injured animal can be detected even more accurately, allowing the shark to zero in on potential prey.

The popular myth is that sharks are merely eating machines, violent and dumb. While such primitive sharks as dogfish do have tiny brains, others such as white sharks possess surprisingly large ones. One difference between us and them is that the shark's brain is not clumped into a sphere but stretched out longitudinally as a series of connected lobes. Another difference is the way the shark's mental resources are allocated. As we would expect, smell sensitivities comprise a relatively huge percentage of the shark's total capacity; what may be surprising is the size of its optic lobe, located at the centre of everything. Unlike bull sharks, which are nearly blind, white sharks have keen eyesight; hence their preference for hunting in the daytime. Another significant portion of the shark's brain is devoted to the reception and analysis of impulses from the ampullae of Lorenzini and the lateral line system, a network of nerves and water-filled tubes along their sides that sense pressure waves and low-frequency vibrations, such as those created by a fish – or swimmers – in distress.

Besides helping to locate prey, the ampullae of Lorenzini can, according to some scientists, enable sharks to navigate by orientating themselves by the earth's magnetic field.[5] The ampullae were first discovered to be sensitive to electrical

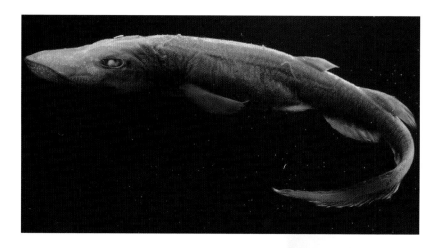

Deep-sea cat shark, also known as longnose cat shark (*Apristurus kampae*), Galapagos, Isla San Salvador. Note the electrical field receptors on the shark's snout.

stimuli by University of Birmingham zoologist R.W. Murray in the 1950s.[6] Two University of Utrecht scientists, S. Dijkgraaf and A.J. Kalmijn extended Murray's work to the lateral line.[7] In 2005, by means of satellite tags, white sharks were tracked from the Farallon Islands all the way to Hawaii, more than 2,000 miles. These tagged sharks followed the current south towards Baja California, then turned west, heading directly for the Hawaiian Islands where they spent the winter, heading directly back to California in the spring. Scot Anderson and Peter Pyle tracked one shark (nicknamed 'Tipfin') making the same journey two years in a row.[8] Until fairly recently, sailors found it easy to miss islands thousands of miles out in the Pacific. That a shark can navigate so reliably in spite of currents and the lack of landmarks suggests highly sophisticated sensory gear.

Other sharks also migrate. Blue sharks from North America make the Atlantic crossing twice a year, preferring to give birth off the coast of Ireland. Great hammerheads (*Sphyrna mokarran*) annually congregate in their thousands, like conventioneers, in

Hammerhead sharks off the Cocos Islands, Costa Rica, 1994.

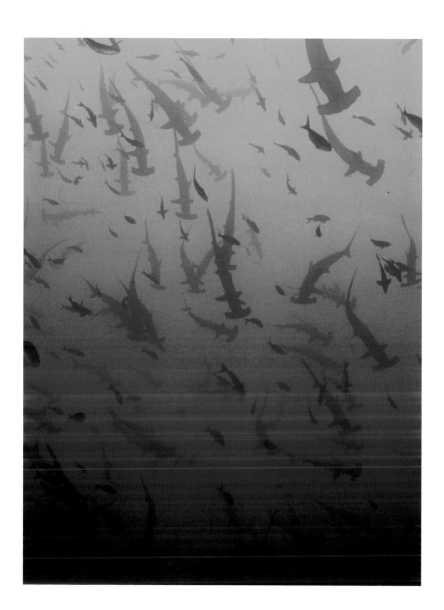

the Sea of Cortez and off the coast of Costa Rica. Since these sharks have hardly changed since the Jurassic period, their astonishingly accurate navigational abilities must pre-date ours by many millions of years. Might we find something to learn from them? It seems possible.

Our earliest studies of sharks were recorded by Aristotle who, among other occupations, was an excellent naturalist. Since sharks are rarely observed in the act of reproducing, Aristotle's description of their copulation is particularly admired. Although he probably did not witness the act himself, he accurately records that 'cartilaginous fishes lie down side to side and copulate belly to belly'.[9] Aristotle also distinguished between males and females on the basis of the males' dual appendages, which came to be called 'claspers' because of their shape – although, as Aristotle made clear, they didn't clasp at all.

Nor, as it turns out, are male sharks essential to reproduction. Parthenogenesis, or 'virgin births', instances of an egg or embryo developing without any genetic contribution from a male, have been attributed to both hammerheads,[10] black-tip

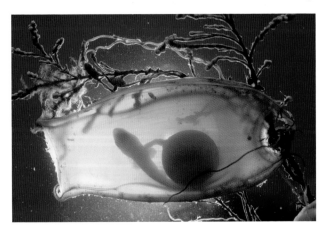

The egg case of
a swell shark,
*Cephalosyllium
ventriosum.*

34

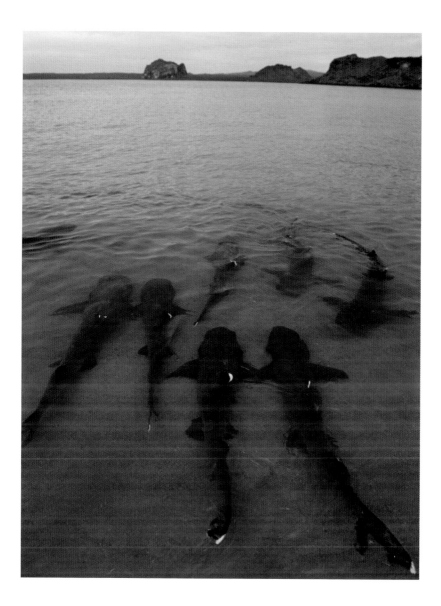

reef sharks and bonnetheads, the more recent occurring in a Nebraska aquarium where a shark captured more than three years earlier gave birth.[11] Beyond the laboratory or an isolated aquarium, we can scarcely imagine a place where a female shark cannot find a mate, but this surprising ability in sharks does suggest that 'primitive' systems may enjoy survival talents that we have yet to discover.

Quite apart from their potential usefulness to us, a great many shark species have achieved levels of adaptive brilliance, if not perfection. Blue sharks (*Prionace glauca*) are among the most beautiful creatures on earth – not only for their colour, a deeply satisfying cerulean, but also for their sinuous ease of movement. With their wide eyes, blue sharks appear permanently curious, as indeed they are, to the extreme discomfiture of shipwrecked sailors. Another curious species even more feared by survivors of shipwrecks and downed aircraft is the oceanic whitetip (*Carcharhinus longimanus*). Oceanic whitetip sharks are believed to have the keenest ability to sense sound (whether they hear it or feel its vibrations is less certain), congregating at the scene of a wreck from as far as 80 miles away. The much-dreaded tiger shark (*Galeocerdo cuvier*) is the world's champion omnivore, known to consume not only fish, turtles, albatrosses and surfers but also metal cans, number plates and, in one famous instance in the eighteenth century, an entire suit of armour. Hammerhead and bonnet sharks operate like electronic spy planes. These sharks have such highly developed electrical sensors in the ampullae of Lorenzini dotting their stretched-out heads that they specialize in hunting skates and rays buried under a layer of sand. The sharks sense the tiny voltage given off by their hidden prey, then hover over the spot, whisking away the sand with their tails and fins to flush out their next meal. When we consider that so many shark species

have remained unchanged for 50 million years or more, it seems logical to conclude that they're at or near their ideal state of evolution, supremely adapted to their tasks.

The skin of sharks is another brilliant innovation – if a design feature from the Jurassic period can be considered an 'innovation'. Unlike fish scales, sharkskin actually consists of denticles, like teeth, that reduce turbulence and thus improve swimming efficiency. Dermal denticles also make for a far tougher hide than any other protective surface. Rubbed from front to back, sharkskin feels smooth, the better to swim with. When brushed from back to front, however, these denticles will rub our own skin raw – the better to discourage contact.

Even more crucial to the shark's successful design is its cartilaginous skeleton. Sharks have no bones in their bodies but possess a softer, lighter frame made of cartilage. The purpose of this is buoyancy. Typically, bone has twice the specific gravity of water: it therefore sinks. Shark cartilage, however, is only slightly denser than water, making it far easier to balance with lighter-than-water organs such as the liver. A shark's liver is

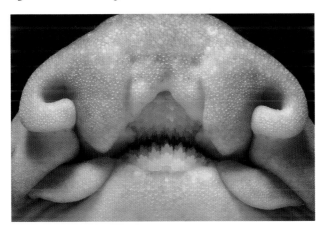

Nostrils and mouth and teeth of crested horn shark or crested bullhead shark (*Heterodontus galeatus*) at night, South Australia, Great Australian Bight.

immense – sometimes as large as 25 per cent of the animal's total weight – since its purpose is not merely to filter blood but to act like an internal balloon. The liver contains light tissue and fluids. At least one species of shark has been found to retain air for buoyancy. The sand tiger shark (*Carcharias taurus*) rises to the surface to swallow air, which it then holds in its stomach, enabling it to hang motionless in the water.

All sharks are slightly negative in buoyancy. Unless they swim, or develop the clever technique of swallowing air, they sink. Consequently, sharks are equipped with thicker, more powerful fins to provide lift. Sharks' pectoral fins are huge relative to those of other fish, extending like wings or long paddles. The pectoral fins of the oceanic whitetip are so long that its Latin name, *Carcharias longimanus*, refers to its 'long arms', its pectoral fins wide as wings. Although the market for sharks' immense, sturdy fins may well be a contributing factor to their demise, we can still appreciate these hydro-nautical appendages for reasons beyond their use as a base for a gelatinous soup. Pectoral fins give steering and lift. The caudal and dorsal fins on the top and the anal fin on the bottom provide stability, helping to prevent yawing and rolling. All propulsion comes from the tail, but here sharks vary widely. At one extreme are the speedy lamnid sharks – white sharks, porbeagles, salmon sharks and (speediest of all) the two species of makos – all with pointed noses and tails of equally proportioned lobes. At the other extreme are the slower species, including long-distance swimmers like blue sharks and the languid leopard sharks with tails of very different-sized lobes to accommodate their leisurely swimming pace. Oceanic whitetips appear particularly effortless as they make their sinuous approach.

While many larger species of shark must always keep moving along, using their body's propulsion to push water into their

gills, enabling them to breathe by a process known as ram ventilation, other species are able to hang motionless or even rest on the bottom. Lemon sharks and bull sharks, for instance, can pump water over their gills by opening and shutting their mouths, allowing them to lie still on the bottom, whether for ambush, relaxation or sleep. Some species – particularly the angel shark and wobbegong (not surprisingly, an Australian Aborigine name) – have the same ability as the skate and stingray to partially bury themselves in the sand and use their unusually strong throat and gill muscles to pump water over their gills.

More surprising is the discovery that prowling sharks, as opposed to lurkers, also indulge in apparent naps. In 1969 a free-diver named Ramon Bravo found a cave full of snoozing sharks near Isla Mujeres, off the Yucatan. His observations were confirmed by the famous 'shark lady', marine biologist Eugenie Clark. Clark identified the species as the non-sedentary Caribbean reef shark (*Carcharias perezi*). She also discovered that the particular caves in which the sharks liked to doze contained water with high oxygen and low salinity, perhaps due to upwellings of fresh water from the onshore aquifer. Since motionlessness is so rare in Caribbean reef sharks, Clark speculated that the high oxygenation made respiration easier and

Wobbegong shark (*Orectolobus maculatus*) head-on, Australia.

A sleepy whitetip shark rests deep in an underwater cave.

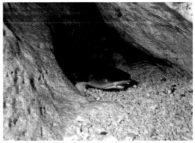

might be producing a narcotic effect. Subsequent research teams have observed three and possibly four species besides the Caribbean reef shark in the Isla Mujeres caves: the lemon shark (*Negaprion brevirostris*), the blue shark (*Prionace glauca*), the tiger shark (*Galeocerdo cuvier*) and possibly the bull shark.[12] The presence of such true pelagics (ocean-going fish) as blue and tiger sharks seems particularly surprising.

Whether sharks sleep remains a mystery, and one that depends on how we define 'sleep'. Although the Isla Mujeres sharks were dubbed 'sleeping sharks', divers reported that the sharks in the caves were always watching, their eyes following the divers. But then, so might the eyes of inebriates, or frequenters of an opium den. Were the sharks conscious? Is eye tracking an automatic response in sharks? Do any sharks 'sleep' as we understand the term? Without hooking them up to electroencephalographs, we can never be sure. Nor is Eugenie Clark's theory about oxygen narcosis supported by the evidence of other species, in other places, quietly respiring. In scattered locations across the Pacific and off Cocos Island of Costa Rica, whitetip

Greenland shark.

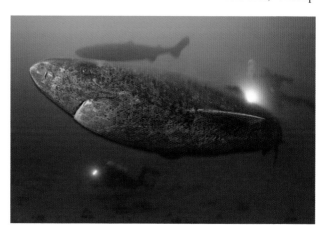

reef sharks (*Triaenodon obesus*) have been discovered in caves stacked up like somnolent logs, but none of these caves enjoy highly oxygenated water similar to those at Isla Mujeres. So what could they be doing in that cave? Cuddling perhaps, or bonding? We are so lacking in research data about shark behaviour and physiognomy that we can only speculate, basing our conclusions on little more than our own mammal models. Do sharks socialize? Do they need a little shut-eye to feel on top form? Such questions call attention to the limits of our own conceptual frames.

Speaking of sleeping sharks, those called 'sleepers' don't. Once believed to be sluggish bottom dwellers, all eighteen species of sleeper sharks of the *Somniosidae* family are actually stealth predators. Entirely black with equal-sized dorsal fins and floppy caudal fins, sleeper sharks move very slowly so as to remain undetected. Pacific sleeper sharks (*Somniosus pacificus*) of the Bering Strait and Chukchi Sea prefer to swim vertically, up and down the water column, presumably to surprise their prey. Pacific sleepers grow to be seven metres long; Greenland sharks (*Sominus microcephalus*), their first cousins, to six metres. It's unclear whether these huge sharks would be a danger to humans since so few of us bathe in their waters. Still, whale, walrus and seal meat have been discovered in their stomachs. The long-distance swimmer Lynn Cox was quite worried about Pacific sleepers when she made her historic swim between Little Diomede Island, belonging to the US, and Big Diomede Island, then part of the USSR, in 1987.[13] Whereas polar bears can be spotted quite easily as white spots paddling across a black sea, Pacific sleeper sharks are black things that rise from below.

Such sneakiness is also the secret of success for the cookie-cutter sharks (*Isistius brasiliensis*, *Isistius labialis* and *Isistius plutodus*). Like their cousins the sleeper sharks, cookie-cutters have equal-sized dorsal fins and floppy tails. They're not built for

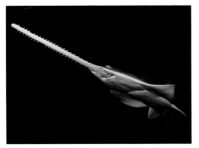

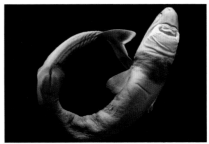

Sawfish (*Anoxpristis cuspidata*). The saw is used for burrowing and stunning fish.

The cookie cutter shark (*Isistius brasiliensis*) cuts pieces off prey with its sharp jaws.

speed but for stealth. Cookie-cutter sharks are rarely more than a third of a metre in length but they specialize in much larger prey. They approach the prey undetected before, as we have already seen, cork-screwing out a mouth-shaped bite. Many cookie-cutters are heterodontal, meaning that they have entirely different-shaped teeth on the top and bottom of the mouth. The top teeth are hook-shaped for grabbing and keeping hold of the meat, and the triangular lower teeth are used for orbital cutting. Cookie-cutters routinely bite chunks out of dolphins and whales. According to naval reports, cookie-cutter sharks have even attacked the rubber sonar domes on nuclear submarines.[14]

Sawsharks are ingenious predators in their own way. Their long snouts, which look like motorized hedge clippers, actually serve as both defensive weapons and sensors for detecting the faint vibrations and magnetic fields of crustaceans buried beneath the sand. Interestingly, five of the ten known sawfish species are native to Australia, that zoologically experimental land that gave us the platypus. These cartoonish curiosities include the longnose sawshark (*Pristiosphorus cirratus*), which frequents bays and estuaries, and the freshwater sawfish (*Pristis microdon*), which is sometimes classified as a ray and is in any case nearing extinction. Many highly localized or niche species are critically threatened by loss of habitat and overfishing (often

by-catch or inadvertent killing). Such incidental extermination seems even sadder and more regrettable when we consider that creatures like sawsharks date back to the Jurassic period.

Angel sharks, classified among the primitive squaliniformers, are even older, going back to the Triassic, more than 200 million years ago. Many angel sharks appear as primitive as they are, particularly *Squatina california* and *Squatina japonica*, which are among the creatures that cast our imaginations back to all those improbable illustrations filling the plates of our childhood dinosaur books, those creatures with strange wings and humps and crowns on their heads, like designs that shouldn't have left the drawing board. The Port Jackson shark (*Heterodontus portusjacksoni*), yet another denizen of Australian waters, looks like some kind of unnamed mythological beast with the head and glower of a horseshoe crab and the body of a shark dressed in army camouflage. The Port Jackson shark gets its genus name from its differing kinds of teeth: molars in the back for crushing invertebrates and pointed teeth in the front for biting and holding on. Other primitive sharks look like fat bats in flight with their pectoral fins turned up like wings. The prickly dogfish (*Oxynotus bruniensis*) has a particularly bat-like set of teeth and a fiercely focused expression.

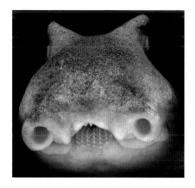

Face of a Port Jackson shark.

Deep Sea Ghostshark (*Hydrolagus novaezelandiae*).

All sharks are predators and are therefore armed, but the eeriest in appearance is probably the goblin shark (*Miksukurina owstoni*). Named by the Japanese fisherman who first discovered it in the so-called Black Current off Yokohama, the goblin shark is (thankfully) rarely seen. A flat, elongated spike like a flat sword extends from its forehead. Perhaps to compensate for the obstruction of its weird snout, its jaw – filled with long, narrow teeth – projects out, creating the impression of a vampire in need of orthodontia. As Richard Ellis puts it in his excellent *Book of Sharks*:

> This seems to me the strangest of all the sharks. It looks like some kind of prehistoric survivor, an experiment in shark design that doesn't seem to work. And yet, by definition, it does work. *Triceratops*, the dinosaur with three horns, is long gone, as are *Pteranodon* and hundreds of other 'impossible' animals. There is little that can be said about this mysterious shark, because so little is known about it. And yet, we have the most curious, incontrovertible fact of all: *Mitsukurina* lives.[15]

Among other unlikely varieties is the pyjama shark (*Poroderma africanum*), whose striking longitudinal stripes leave doubt about the origin of its name, and the taillight shark (*Euprotomicroides zantedeschia*), whose luminous gland would seem to make stealth difficult, particularly as this shark makes its home in the pitch black below 365 metres. Interestingly, the taillight shark has been found in only two small circles of ocean, one off the western side of the Cape of Good Hope, the other off Argentina, which happen to be coastlines that were at one time (about 200 million years ago) contiguous. A cousin of the taillight shark, the pygmy shark (*Eurotomicrus bispinatus*) also occupies isolated circles of ocean, having been found in 24 scat-

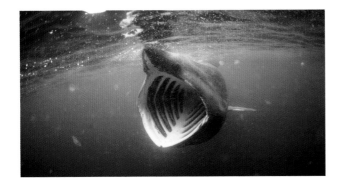

Basking Shark
(*Cetorhinus max-
imus*) in open-
maw feeding
mode, Isle of
Man, UK.

tered locales in the equatorial and southern oceans around the
world.[16] But since pygmy sharks are the size of a child's hand
and dwell in some of the deepest parts of the sea, we still have a
lot more to learn about them.

The three largest sharks are not biters at all but plankton
feeders. The basking shark prefers cool water and occupies wide
bands of ocean well north and south of the equator, swimming
slowly with its giant maw stretched open to suck in small fry.
Since the basking shark swims on the surface, sports a big black
dorsal fin and ranges in size from five and a half to eight metres,
it often alarms people in small boats or gazing out from shore.
But it's harmless. Because of its preference for the surface (and
therefore for maximum buoyancy), the basking shark enjoys
the distinction of having the world's largest liver.

As though by some marine Treaty of Tordesillas (the 1494
agreement in which Spain and Portugal divided the globe along
lines proposed by the Vatican), the whale shark (*Rhincodon
typhus*) pursues plankton in exactly the band of ocean that the
basking shark avoids. The whale shark is the biggest fish in the
sea (whales are mammals) and yet it is entirely benign. These
slow-swimming, spotted blue beauties often reach nine, and

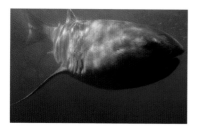

Megamouth shark (*Megachasma pelagios*) off California.

The Frilled shark (*Chlamydoselachus anguineus*), has three-pointed holding teeth, continental shelf, Tasmania, Australia.

occasionally fifteen, metres in length, and yet it's difficult to think of them as predators at all, unless you happen to be a baby shrimp or squid or one of the other tiny animals that comprise the plankton they gulp.

Megamouth is so rare and so recently discovered that its name, *Megachasma peligios*, reveals virtually all we know about it. Big mouth, deep ocean. Megamouth was first discovered in 1976 by a naval research vessel off Hawaii whose sea anchor, a huge parachute appliance deployed at 150 metres, was swallowed by the shark. The sailors hauled in their sea anchor and found a four-metre creature, unlike any other shark, with a mouth as wide as its head and lots of tiny teeth. This specimen marked the discovery of not just a new species but also a new genus and family of shark. Only three other megamouths have been discovered since.[17]

What is most astonishing about sharks is not their ferocity but their diversity. Even with so many species swimming around, we're still discovering new ones. Some of these species are indeed the monsters of our nightmares – if not in behaviour then surely in appearance. But, in fact, sharks outstrip our imaginations not only in the terror that they induce, or in their improbable shapes and designs, but also in their connection to an evolutionary past so distant as to defy human comprehension.

2 Deities and Demons

No other animal elicits such fascination and fear as the shark. Part of the reason is its power. With the occasional exception of humans and killer whales, the shark rules among all the myriad life forms of the sea. Another part of the shark's hold on our imaginations derives from its elusiveness. Even now, we know relatively little about shark behaviour. They appear suddenly, often out of the gloom of deeper water, at which point they may flick away or circle. Or they may circle and attack, or hit and run. Or they may remain to devour. But what appears as unpredictable or capricious is really an indication of our own ignorance. The response in the West to this ignorance has been the castigation of sharks as vicious demons of the deep, without much regard for their size or species. By contrast, the cultures that have lived most closely with sharks have traditionally viewed them not as monsters but as religious entities.

Pacific islanders invested sharks with spiritual powers. Like violent storms and volcanoes, sharks were forces over which they had no control. These people couldn't net their beaches or build steel boats any more than they could engineer levees, dikes or sea walls to protect themselves from typhoons and volcanic eruptions. So instead they chose to stand in awe of the natural forces that rendered them helpless. Polynesians of the South Pacific worshipped the shark god, Kauhuhu. The people

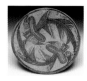

Bowl with hammerhead-shark design, c. 600–800 AD, Pre-Columbian (Panama Cocle).

of Papua New Guinea and the Solomon Islands believed that sharks were embodiments of their ancestors and in some cases ghosts of the more recently departed. The Tlingit of what is now south-west Alaska and the coast of British Columbia used the dogshark as a decorative element to remind themselves of the myth of a woman who was carried off by a shark and subsequently became one. The Songlines of the Australian Aborigines contain references to a bloodstain on the rocks of Chasm Island, where the reddish coloration on the rocks is believed to be evidence of the attack by the tiger shark Bangudya on the dolphin-man, a gentle hybrid.[1] Hawaiians developed the most elaborate beliefs featuring sharks and worshipped them as gods, just as they deified Pele, the fire goddess of the volcanoes. Sharks and volcanoes were seen as uncontrollable natural forces that held the power of life and death. In earlier times the Hawaiians and the Solomon Islanders made human sacrifices, casting ritually dismembered victims or even living ones into the ocean at spots where there were known to be a lot of sharks. Believing that sharks desired human sacrifice seemed logical enough, since sharks periodically took people of their own accord.

For Pacific islanders, sharks have always been part of life: background threats, reasons to be cautious and occasional killers. Travellers between islands accepted that they were unlikely to drown if they were to capsize at sea; an oceanic whitetip would find them first. Tiger sharks paid periodic visits to these tropical islands, snatching a swimmer or sometimes overturning a dugout canoe. The canoe would be found empty and adrift, and people would assume that a shark was the cause. Spear fishermen knew they were especially vulnerable and took precautions. They immediately crushed the skulls of caught fish between their teeth to stop the fluttering of the wounded fish,

and they would suspend all spear fishing for three days after a tiger shark sighting. While the reef sharks that they typically encountered were smaller and less aggressive than tiger sharks, even a minor bite could be fatal without antibiotics or medical care. Polynesian peoples therefore assumed an attitude of respect for the shark's power and majesty within its own watery realm.

That respect could take the form of deification, particularly in Hawaii. In fact, early Hawaiians had nine named shark gods and demigods, not counting the beneficent guardian spirits and family protectors known as *aumakua*. Chief among their gods and goddesses was Ka'ahupahau, who lived near Pu'uloa (now Pearl Harbor) and protected the island of Oahu from other sharks. She and her brother, Kahi'uka (which means 'slapping tail'), were born as humans and later transformed into sharks; however, they retained some memory of their previous lives. While she was still a human, Ka'ahupahau was famous for being a redhead; whether this singularity among Hawaiians was related to her transformation is unclear. What is certain is that imperiousness was part of Ka'ahupahau's characterization. According to legends, worshippers were bringing leis – flower necklaces – to her when a local girl demanded the loveliest of the leis for herself. Scolded for her disrespect, the girl snatched the lei and ran off, offending Ka'ahupahau. When the girl swam out to a rock, the shark goddess spied her and said to the other sharks, 'That girl is spoiled and selfish and has no respect. She deserves to die.' So one of the sharks carried out the goddess's wishes by dragging the girl into the sea and killing her. With this resolution we might expect the legend to end, but the legend of Ka'ahupahau is a complex parable. The shark goddess was still new to her power and divinity when she said that the girl should die, and when she learned of the girl's death, she was

anguished at the glib way she had exercised her power. Ka'ahupahau pledged that sharks would never again attack humans at Pu'uloa. According to myth, the people of Oahu repaid Ka'ahupahau for her protection by feeding her and her brother and grooming them, removing the barnacles and remoras from their skin.[2]

The shark god Kamohoalii could transform himself into human shape. Kamohoalii was the favoured brother of Pele, the fire goddess who, because of the several active volcanoes on the islands, ruled most powerfully over Hawaii. The most sacred spot to worship Kamohoalii was, in fact, on the rim of the Kilauea crater on the island of Hawaii, but at one time every piece of land jutting into the sea on Molokai enjoyed some sort of shrine dedicated to Kamohoalii. Kapen'apua, usually identified as the young brother of Pele and Kamohoalii, was seen as a kind of trickster, able to assume the form of a bird and perform feats of magic, including the calming of two legendary colliding hills that destroyed all canoes that tried to pass between them.[3] Pele's cousin Keali'ikau-o-Kau was the shark god who protected the Ka'u people, on the Big Island of Hawaii, from sharks. The legend tells that he had an affair with a young woman who gave birth to a beautiful, benevolent green shark.

Sharks-as-ancestors myths were common throughout the Polynesian islands. On the Big Island of Hawaii, the main shark god Kua was believed to be the ancestor of the Ka'u people.[4] Of all Hawaiian tribes, the Ka'u could be said to live closest to their origins, since they made their home at South Point, the southernmost spot in the Hawaiian chain and the likely landing place for the original settlers of the islands. So it seems appropriate that they would retain one of the central Polynesian beliefs. In French Polynesia, islanders also believed that their ancestors manifested themselves in the form of a shark called Taputapua,

which could be called upon to take part in family disputes. The common reluctance of spear fishermen to work after a domestic argument follows logically from this belief; the fishermen feared that their angry wives might invoke Taputapua to settle the argument at sea. But sharks as ancestors, the domestication of a deity and a natural threat, must have also helped to bolster the courage of these people who routinely took to the open sea in dugout canoes. Throughout Polynesia, islanders made offerings to the shark gods before ocean voyages, asking for protection and favourable winds during their journeys beyond sight of land. In fact, Taputapua is still thought to be available for emergencies, such as transporting capsized fishermen to shore. It must help the fishermen to believe that their Taputapua, or ancestral spirits, might be available to protect them.

One Cook Island legend, that of Ina and the shark, is commemorated on the country's currency. Ina was the love of Tinirau, the god of the ocean who lived on a floating island. One day, Ina tried to jump into the ocean to swim to Tinirau, but the surf kept flinging her back to shore. So she asked the fish to help her. But when these fish proved too weak to pull her past the waves, she beat them with a stick, scarring them – which is how angel fish acquired their stripes. Next Ina asked a shark to help, and he agreed. Ina brought along coconuts for her journey, and when she became thirsty the shark lifted his dorsal fin for her to crack the coconut. After a while Ina relieved herself; the shark asked her not to do so again. According to the legend, Ina's poor manners explain why shark meat sometimes has a slight urine taste. When Ina became thirsty again, she decided to crack her second coconut on the shark's head. In one version of the story, Ina's repeated attempts to crack her coconut explain how the hammerhead got its head. In another version, her cracking of the coconut explains why sharks have a bump on the tops of

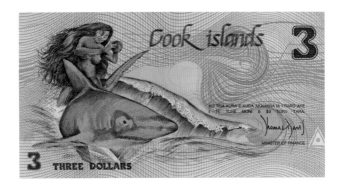

their heads, known to Cook Islanders as Ina's bump. Regardless, the shark had enough of Ina's behaviour and tossed her off his back. Ina would have drowned if not for Tekea the Great, the King of the Sharks, who rose up from the bottom of the ocean to save her and transport her the rest of the way to Tinirau's floating island.[5]

In Sri Lanka the pearl divers attended ceremonies with their local shark charmers before the day of diving. These shark charmers were believed to have hereditary powers from a mysterious higher authority that was recognized and respected by the sharks.[6] No doubt the divers were calmer in the water, more graceful and therefore less likely to attract sharks.

The Marshall Islanders fought religious wars over sharks when one tribe showed disrespect to the sacred shark of another tribe. If, for instance, one tribesman caught and killed the totem shark or ray of a rival tribe, the offended tribe would demand an apology and a pledge that the offence would not occur again. If these terms were not met, then a holy war would ensue.[7]

The coastal people of Papua New Guinea have kept alive the ancient religious practice of shark calling, which is seen as both an act of reverence and proof of manhood and courage.

These people have long believed that sharks contain the spirits of their ancestors, but they have what may seem to us an odd way of showing it. Armed with only a club and a noose on a short pole, men go out to sea (usually alone) in dugout canoes to capture sharks. The fisherman uses a rattle made from shells and coconuts to attract a shark; he then slips the noose over the shark's head and wrestles it into the canoe where, operating in very close quarters, he clubs it to death. Because of the

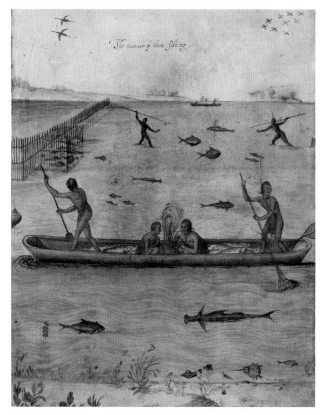

'The Manner of their Fishing'. John White composed this scene by basing it on several studies combining three methods of fishing used by the Algonquin Indians. They used a dip net and spear, by night a fire in a canoe to attract the fish to the boat, and fish weirs. The fish are hammerhead sharks, catfish, king crabs, skate or ray and a sturgeon, which can be found between the mainland and the Outer Banks of North Carolina.

narrowness of the canoes, this ritual requires amazing skill and balance as well as courage. Once ashore, the shark is ritually butchered, with prescribed cuts going to the fisherman's family and the chief, then to the rest of the community. Even today on the island of Kontu, eating a shark killed and prepared in the customary ancient manner is considered a blessing for the whole village.[8]

For Westerners, it is easy to see the Pacific islanders' deification and domestication of sharks as little more than transparent attempts to manage their own fears of the powerful, capricious forces encountered in their daily lives. Aboriginal people, in an effort to explain the mysteries of shark behaviour, attributed human qualities and chieftain characteristics to sharks, thus imagining not only a great shark like Ka'ahupahau who learns from her mistake, but also family sharks, ancestral sharks, benevolent sharks and saviour sharks. Sharks are both elusive and commonly encountered, so it seems only natural that they would inspire divinity myths. Whereas the American and European response, particularly in the twentieth century, has been to sensationalize shark encounters and fan the flames of shark terror, Pacific islanders have wisely preferred to minimize their fear of the unknown and the unpredictable by taming it through mythology.

More complicated are the shark-man myths, common throughout the South and Central Pacific. In ancient Japan, the mythological god most feared was the storm god known as 'shark-man', who betrayed people's trust in nature by transforming typically benign natural forces of wind and rain into an overwhelmingly destructive storm like a typhoon. In the Solomons, myths divided sharks into good and bad ones. The good sharks, often believed to be the spirits of ancestors, were said to guide fisherman back to safe harbour and protect swim-

mers from alien sharks, even to transform themselves into stingrays and transport endangered swimmers to shore. But in other myths sharks represent not benevolence but the two-faced malevolence of our own kind, with evil men taking the form of sharks to commit their murders and changing back to human form during the day. Hawaiian mythology includes numerous stories of shark-men, identifiable by the pattern of shark jaws on their backs, who were able to alter their forms, sometimes under the full moon, like werewolves. A common event in many of these myths features a strange man warning swimmers to stay out of the water because of sharks. When the swimmers scoff at the stranger and ignore his warning, he transforms himself into a shark and devours them. As in were-wolf mythology, the demonic masquerade is discovered when villagers hunt the shark, only later to find a strange man, pierced with their spears, dying on the beach.

The patterns that exist across the Pacific represent sharks as a higher power, whether a deity or merely a powerful force of nature. The sharks might maim or kill, but the violence they inflict is neither treacherous nor personal. Shark-men are the exceptions and the dangerous aberrations; acts of malevolence, wanton and personal attacks, occur only when sharks are in this unnatural form, hybridized with human qualities such as pride, vengeance, blood lust and cruelty. Ka'ahupahau, not yet fully transformed into the shark deity, reacts angrily and imperiously orders the death of the disobedient girl. The shark goddess is not malicious, however. Once she assumes her new status, she learns from her abuse of power and acquires majesty. By con-trast, the shark-man who haunts the beach, switching back and forth between human and shark forms, is a psychopath or a demon – his anger at being laughed at is only an excuse for doing what he wants to do.

The shared quality of these shark-men and partial transformations is treachery: men using their power, their shark forms, to commit the violence that is harboured in their human hearts. The Pacific peoples recognized that sharks are by nature capable of great violence but not of anything malicious or demonic. Sharks kill randomly and indifferently. Only our own species can muster the desire to commit violence for the perverse pleasure of it. Implicit in the shark-man myths is the belief that it takes a hybrid to make a monster: the natural power and armament of the shark combined with the human possibilities of a Jack the Ripper or an Iago.

Interestingly, Hawaiians of centuries past also contrived challenges to the sharks that they revered. They held gladiator contests between particularly brave young men and the shark gods at what is now Pearl Harbor, on the south shore of Oahu. Into a pen of lava rocks they lured sharks with bait, often including human flesh. They pitted these sharks against swimmers armed with a single spear, tipped with a shark tooth. Since the

Hawaiian shark-tooth club.

A Hawaiian shark-tooth weapon.

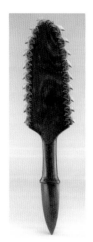

sharks had many teeth and their challengers only one, the sharks usually prevailed, thus reinforcing their majesty and divinity in a cloud of blood and carnage as the crowd looked on. Occasionally, however, a young man with his spear succeeded in slicing open a shark's belly and disembowelling it, in which case human skill and resourcefulness would be celebrated for having defeated those of the god.

A similar desire, not just to get the occasional edge over nature, but to rule it, lies at the base of our Western attitude towards sharks. Within the European tradition, sharks have been demonized as far back as Greek mythology. Lamia was a beautiful queen of Libya pursued by the ever-lecherous Zeus. When his wife, Hera discovered their involvement and the children they'd had together, she stole the children. Lamia went

Histoire Naturelle,

An illustration from Diderot's *Encyclopaedia* showing a hammerhead shark.

mad from grief, becoming a demon that snatched, killed and ate the children of other mothers. Her mania altered her features, making her hideous; it even changed her form. The word *lamia* means 'dangerous lone shark'. Often Lamia is described not as a shark or sea creature, but as a night-haunting demon that preys on young children, a kind of bogeywoman. Still, it's intriguing to see this early connection between female power, motherhood driven to murderous madness and the shark. Later pluralized, Lamia became the ghostly, man-eating, multiple monster, Lamiai, whence the lamnid sharks (including the white shark) derive their name.[9]

Although Herodotus, writing in 492 BC, described hordes of 'monsters' devouring the shipwrecked soldiers of the Persian fleet, our contemporary terror of sharks really dates from another, much more recent, war – World War II.[10] The numbers of actual deaths due to shark attacks were minuscule in comparison to the tens of millions killed, starved and exterminated in the course of the six-year, worldwide war; still, the fear of sharks loomed large in the imaginations of British, Japanese and American air force and naval personnel. The US Navy devised several 'shark repellents' which were merely smelly dyes that briefly clouded the water. These were widely used, although none of them proved the least bit effective. But sailors and airmen needed something to believe in when they ventured into 'shark-infested waters'.

This popular terror can be traced to three major sinkings: two British transports torpedoed off South Africa early in the war and one US cruiser torpedoed in the Philippine Sea just days before the Japanese capitulation in 1945. The first of these disasters was the *Laconia*, a Cunard liner converted to a British armed merchant cruiser and transport, attacked and sunk on 12 September 1942 by a German U-boat 200 miles south of

Ascension Island, just below the equator. The Laconia was carrying 2,715 passengers, including 1,783 Italian prisoners of war. She went down quickly, destroying many of the lifeboats. Still, most of the passengers made it into the water. Appalled by the vast number of survivors bobbing in the ocean, the U-boat crew surfaced and began picking up survivors. It also radioed British ships in the area, alerting them to the disaster. Perhaps because of the many hundreds of Italian POWs, a second U-boat arrived to help in the recovery. Unfortunately for the survivors, these U-boats were sighted by an American air patrol and, although the German submarines displayed red crosses on their decks, American aircraft began to bomb and strafe them. The German response was to hastily force the survivors back into the sea. It was believed that the sound of the *Laconia*'s exploding boilers, rather like a dinner bell, first attracted the sharks. Whatever the reason, oceanic whitetips arrived soon after the sinking and remained close by, persistently circling and occasionally attacking, for the three days until the last survivors were rescued. There were 1,111 survivors. Of the 1,672 who died, an unknown number were victims of shark attacks. No details about causes of death were ever published. In fact, wartime censorship suppressed most information about maritime disasters during World War II.

Considering the lack of published information about sinkings and downed aircraft, it seems surprising that the shark attacks associated with wartime maritime disasters were so widely known. But they were avidly repeated, perhaps even exaggerated, because the sailors and airmen knew that military censorship suppressed and minimized the frightening details. Eyewitness reports contained in the log records of the *Alfonso de Albuquerque*, the ship that rescued survivors of the *Nova Scotia* sinking, were not released for years after the British transport

went down. The *Nova Scotia* was torpedoed off Durban, South Africa, on 28 November 1942; it remains the worst maritime disaster to have occurred in that region. Of its 1,000 passengers, only 192 survived. According to the rescuing ship's log, at least a quarter of those who died in the water were killed by sharks. Oceanic whitetips are common in the deeper waters of the Indian Ocean. Because of its many whale-processing factories, Durban also enjoyed considerable attention from white sharks and huge tiger sharks, hordes of which would follow the whaling ships into port. So, added to the usual reluctance of military authorities to allow publication of information that might be considered inflammatory was the historical local resistance to any linkage between whaling and shark attacks on Durban beaches. According to researcher Marie Levine's crucial study, more than half of all South African shark attacks from 1940 until 1975 occurred on the Natal coast and when the whaling stations closed, in the late 1970s, shark attacks fell off sharply in the Durban area.[11] And yet local rumour reported these statistics well before the South African authorities released information, just as naval gossip had proved the more reliable source for details of naval disasters.

The sinking of the uss *Indianapolis* resulted in the most sensational (and sensationalized) shark attacks in recorded history. The Benchley–Spielberg character Quint, from *Jaws*, summarizes the *Indianapolis* story this way, intending to emphasize the most inflammatory details:

Eleven hundred men went into the water . . . Didn't see the first shark for about a half an hour. Tiger. 13-footer . . . shark comes to the nearest man, that man he starts poundin' and hollerin' and screamin' and sometimes the shark go away . . . but sometimes he wouldn't go away.

Sometimes that shark he looks right into ya. Right into
your eyes. And, you know, the thing about a shark . . . he's
got lifeless eyes. Black eyes. Like a doll's eyes. When he
comes at ya, doesn't seem to be living . . . until he bites ya,
and those black eyes roll over white and then . . . ah then
you hear that terrible high-pitched screamin'. The ocean
turns red . . . and they rip you to pieces. You know by the
end of that first dawn, lost a hundred men. I don't know
how many sharks, maybe a thousand. I know how many
men, they averaged six an hour . . . I bumped into a
friend of mine, Herbie Robinson . . . I thought he was
asleep. I reached over to wake him up. Bobbed up, down
in the water just like a kinda top. Upended. Well, he'd
been bitten in half below the waist . . . So, eleven hundred
men went in the water; 316 men come out and the sharks
took the rest, June the 29th, 1945.[12]

The actual date was 30 July 1945, and considerably fewer than
1,100 men made it out of the ship alive. The *Indianapolis'* total
crew was 1,196. Since the ship sank in twelve minutes, just after
midnight when most crewmen were asleep, historians have esti-
mated that 300 men were trapped below decks or immediately
drowned. About 900 men survived the sinking, and 317 ulti-
mately survived the ordeal,[13] meaning that 600 men died in the
water. Since the *Indianapolis* had been on a secret mission to
deliver parts of the atomic weapon 'Little Boy' to the staging area
on the island of Tinian, she was not listed on regular navy sched-
ules and was therefore vulnerable to navy error. Her sos signals
were ignored; she was overdue for three days but not listed as
missing when she failed to show up at Leyte, in the Philippines.
The us Navy had reports of Japanese submarines in the vicinity
but failed to inform the *Indianapolis* or to provide destroyer

escort, as requested by the ship's captain. The US Navy court-martialled the captain rather than admit that any of its own lapses and procedures might have been to blame for leaving 900 men drifting in the open ocean without food or water for nearly five days, during which time the survivors sustained four full days of shark attacks. Captain McVey was restored to duty a year after the war but took his own life in 1968.[14]

Perhaps 200 sailors from the *Indianapolis* were victims of shark attacks, an average of about 50 men per day.[15] No doubt many of the other 400 casualties were consumed by sharks after dying from other causes: untreated wounds, hypothermia, dehydration, kidney failure from drinking salt water and drowning. There were very few rafts. The life jackets used by the US Navy became waterlogged within a day or two. By the time the first aircraft spotted the survivors, many hundreds of sharks had gathered. The survivors were too tired to fight, and attacks were routine. The stories about these shark attacks are grisly – sharks assaulting inflatable rafts, sharks attacking in waves – but even so, twice as many sailors died from exposure to the elements as from exposure to hungry sharks. Yet it's the sharks – not the other natural causes of death or the Navy's grotesque failures – that have made the USS *Indianapolis* famous.

The actual survivors of the disaster were much less dramatic than Quint, Benchley's fictional survivor, and focused less on the sharks' role in the general misery and loss of life. Of his 2,800-word statement submitted to a Senate inquiry in 1999, *Indianapolis* survivor Woody Eugene James devotes relatively little attention to the sharks:

> Day two was when the sharks showed up, in fact they showed up the afternoon before but I don't know of anybody being bit. Maybe one on the second day but we just

know we'll be picked up today. They've got it all organized by now, they'll be out here pretty soon and get us, we all thought. The day wore on and the sharks were around. Come nighttime and nobody showed up. We had another night of cold, prayin' for the sun to come up. What a long night . . . The sun finally did rise and it got warmed up again. Some of the guys been drinkin' salt water by now, and they were goin' bezerk. They'd tell you big stories about the *Indianapolis* is not sunk, it's just right there under the surface . . . The day wore on and the sharks were around, hundreds of them. You'd hear guys scream, especially late in the afternoon. Seemed like the sharks were the worst late in the afternoon than they were during the day. Then they fed at night too. Everything would be quiet and then you'd hear somebody scream and you knew a shark had got him . . . It didn't ever get any cooler in the daytime. In fact, Newhall asked me, he said, 'James, do you think it's any hotter in hell than it is here?' I said, 'I don't know, Jim, but if it is, I ain't goin'.[16]

Like those of the *Nova Scotia* and the *Laconia*, the 900 survivors of the *Indianapolis* were left far too long in the ocean, where shark attacks were only one of their problems. Without in any way trivializing the horror and the helplessness of the victims, we must remember that the open ocean is the sharks' habitat, where they rule as apex predators feeding on whatever they find. The vibrations from explosions followed by thrashing men would have attracted sharks. The massive bleeding of the wounded would certainly have excited them. Human carcasses in the water serve as excellent appetizers. Had the crew of the *Indianapolis* been rescued within a reasonable period, shark predation would have been minimal.

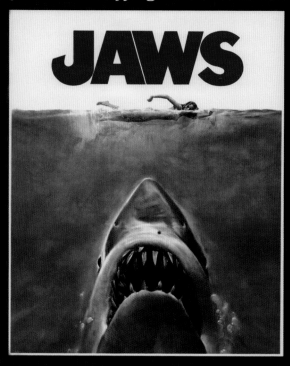

The terrifying motion picture
from the terrifying No.1 best seller.

JAWS

ROY SCHEIDER **ROBERT SHAW** **RICHARD DREYFUSS**

JAWS

Co-starring LORRAINE GARY · MURRAY HAMILTON · A ZANUCK-BROWN PRODUCTION
Screenplay by PETER BENCHLEY and CARL GOTTLIEB · Based on the novel by PETER BENCHLEY · Music by JOHN WILLIAMS
Directed by STEVEN SPIELBERG · Produced by RICHARD D. ZANUCK and DAVID BROWN · A UNIVERSAL PICTURE ·
TECHNICOLOR® PANAVISION®

PG PARENTAL GUIDANCE SUGGESTED
SOME MATERIAL MAY NOT BE
SUITABLE FOR PRE-TEENAGERS

ORIGINAL SOUNDTRACK AVAILABLE ON MCA RECORDS & TAPES
...MAY BE TOO <u>INTENSE</u> FOR YOUNGER CHILDREN

The shark species implicated in the *Indianapolis* attacks included tiger sharks, oceanic whitetips, short-fin makos and blue sharks. Of these attackers, oceanic whitetips were the most numerous and, with their large rounded dorsal fins, most easily identified. The *Indianapolis* casualties attributed to oceanic whitetips are estimated to be at least 80 or 90 which, combined with their many victims on the *Laconia* and the *Nova Scotia*, would make the oceanic whitetip the greatest man-eater of all sharks – not because of any fondness for human flesh, but because our wartime maritime disasters left people so vulnerable for such long periods of time.

According to mythology, the rogue shark prowls the beaches, haunts the harbours and even swims upstream in his monstrous quest for innocent people to maim and kill. *Jaws* uses this myth as its central sensation and conceit. In both the Benchley novel and the Spielberg film, the shark-protagonist is a white shark of monstrous dimensions that besets a popular tourist island very much like Martha's Vineyard or Nantucket, off the coast of Massachusetts. In fact, large white sharks do make their way into these waters every summer as they follow whale and fish into the deep-water eddies off the Gulf Stream; however, no shark attacks have ever been recorded at Nantucket or Martha's Vineyard. The precursor for the *Jaws* monster was not a contemporary event but a series of attacks that occurred in New Jersey in 1916. Within twelve days in July of that year, a shark or sharks mauled five swimmers, killing four and attracting the attention of millions, including President Wilson.

Before becoming president, Woodrow Wilson had been governor of New Jersey, as well as president of Princeton University, and he summered on the Jersey shore. In 1916 he was in Asbury Park, with a large contingent of reporters loitering nearby, picking up occasional dry news about trade policy or US

Poster for Steven Spielberg's 1975 film *Jaws*.

neutrality. The first attack occurred in Beach Haven. Charles Vansant, a recent graduate of the University of Pennsylvania, was swimming about fifteen metres out, just beyond the surf line. Onlookers saw the shark rapidly approaching. Vansant was dragged beneath the surface. He was rescued but died en route to hospital.[17] Five days later, on 6 July, another young man, Charles Bruder, was attacked in front of a popular hotel in Spring Lake, an opulent resort 45 miles north of Beach Haven. This was much closer to the place where Wilson was summering and the press corp was encamped. Bruder was a hotel employee and a vigorous swimmer. He was alone and about 120 metres from shore when he was attacked. The shark severed both his legs; the water was so red that witnesses at first concluded that a red canoe must have capsized and the paddlers were floundering.[18] Over the following weeks these details were repeated many times in the press.

During the same week, children in New York City were dying at the rate of one per hour from a polio epidemic.[19] The Battle of the Somme also began that week; on 1 July the British Army suffered 57,470 casualties, including 19,240 deaths. Yet the American press was obsessed with 'the man-eaters' on the New Jersey shore. Perhaps it was the proximity of the President. Perhaps newspaper editors sensed the public's desire to be distracted from more widespread horrors.

The third day of shark attacks was 12 July. The mouth of Matawan Creek is located on Raritan Bay, not far from New York harbour. The creek is a tidal inlet, extending about ten miles and becoming increasingly fresh-water. An eleven-year-old boy and the 24-year-old man who subsequently tried to recover his body were killed in the fresh-water section by a shark of about 2.5 metres. A second boy was subsequently badly mauled a few hundred metres downstream, but he made a full

'Pneumonia strikes like a man eating shark led by its pilot fish the common cold: Consult your physician'. WPA poster, 1937.

recovery. The shark was assumed to be the same one that had attacked Vansant and Bruder, and rewards were offered for the criminal. Locals of all ages patrolled Matawan Creek with shotguns at the ready. President Wilson called a cabinet meeting, at which they decided to mobilize the US Coast Guard and the revenue boats of the Treasury Department in the search of the killer shark. Fishermen landed hundreds of sharks, including many sandbar sharks, dusky sharks, bull sharks and large but harmless thresher sharks. Fishing fleets had reported an unusually

large number of sharks following the schools of baitfish along the coast that year. On 14 July, in Raritan Bay, an amateur fisherman named Michael Schleisser hooked a juvenile white shark and killed it with a broken oar. The shark was only two metres long (small for a great white) but its stomach contained human remains. Since no other shark attacks occurred, Mr Schleisser's shark was assumed to be the Matawan shark as well as the attacker at Beach Haven and Spring Lake – the 'rogue shark' that had been hunting people along that stretch of coast.

Unfortunately for the species concerned, no attempts were made to compare the remains retrieved from the shark with the victims' wounds. The shark's capture in proximity to the mouth of Raritan Creek was evidence enough to conclude that, having savagely attacked two swimmers along the coast, the same shark had penetrated inland to seek out other unsuspecting victims. The newspapers equipped each of these victims with a sympathetic or heroic life story. In fact, the behaviour of the shark in Matawan Creek strongly indicates that it was a bull shark, not a white shark. Bull sharks often pass between salt water and fresh water, whereas white sharks lack the biological mechanisms to breathe in fresh water. Bull sharks also like to hang nearly motionless in muddy holes, while white sharks must swim continuously to stay alive. The point here is not to rescue the reputation of the great white shark, nor to damage that of the bull shark, but to recognize that myth-making in this famous set of incidents was based not on science but on a mass eagerness to believe. The rogue shark myth, with the tragedy of four manly young Americans killed and a culprit shark caught and blame assigned, offers a dramatic completion and catharsis. But beyond the ways that we may transfer real fears of world wars and epidemics of infantile paralysis onto fishier notions such as sharks as serial killers, there exists the question of why

we like to scare ourselves. Pacific Island cultures, often labelled as 'primitive', don't drive themselves to distraction by magnifying the dangers of shark attack or volcanic eruptions, or by dramatizing the gruesome details of shark bite or immolation by lava. Fright entertainment, the creating and inflaming of phobias, is a Western cultural norm, not only because our circumstances allow us to choose whether to go in the water or live in the shadow of an active volcano, but also because we're haunted by visions of hell and – at least since Freud – fascinated by our own inner recesses and dark depths.

3 Our Sensational Imaginations

The shark is depicted as a malevolent force in literature and film. Herman Melville makes much of the shark's belly in *Moby-Dick*'s pattern of associations between 'transcendent horror' and 'ghastly whiteness'. Jules Verne's *Twenty Thousand Leagues Under the Sea* features the *grand chien de mer* and other 'formidable dogfish' as 'iron-jawed' monsters bristling with teeth, so terrible that not even Professor Aronnax the naturalist can observe them dispassionately. In Hemingway's *Islands in the Stream*, the hard-drinking deckhand is redeemed when, with the use of a tommy gun, he saves the narrator's teenage son from a preternaturally murderous hammerhead. Hungry sharks in a swimming pool (never mind the species) are one of the terrors of Doctor No's household in the James Bond film. As for *Jaws*, both Spielberg's film and Benchley's novel depict a 'rogue shark', which, like the tigers of the Kipling era, develops a taste for human flesh and stakes out a summer resort as its own private hunting ground.

Similar misrepresentations extend to visual art. John Singleton Copley's famous *Watson and the Shark* (1778) shows an oddly handsome but purely fabulous shark about to devour a naked swimmer posed in a way that brings to mind Christ at the crucifixion. Winslow Homer's *Gulf Stream* (1899) shows more accurate sharks, but again it's difficult not to see them as

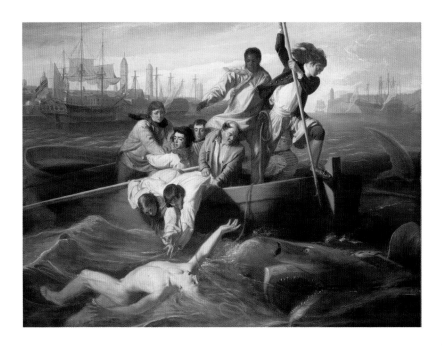

creatures from Hell snapping their jaws at the survivors lying perilously on their damaged boat. Damien Hirst's 1991 tiger shark floating in formaldehyde at least shows an understanding of where to assign the haunting – within ourselves. But none of these depictions shows sharks for what they are: fish going about their business of prowling for and gobbling other marine life. Instead, they become monsters of the deep, used to carry themes or inject an electric element of fright into plots that need a jolt.

Particularly during the nineteenth century, whaling crews felt besieged by sharks that followed them during their voyages and gathered in the hundreds to feast on the whales lashed to the sides of their ships. Since these sharks were typically the

John Singleton Copley, *Watson and the Shark*, 1778, oil on canvas.

71

largest, fiercest species – white sharks, blues, oceanic whitetips and tigers – the sailors had reason to resent them as they worked to butcher the whales from small boats or stood atop the slippery carcasses with the sharks feeding below. If a whale carcass was left for a day undefended, sharks were capable of stripping it to the bones beneath the waterline. This problem was more acute in tropical waters, in the Pacific and Indian oceans, where sharks were more plentiful. Whaling crews worked slowly in Melville's day – the mid 1800s. And there might easily have been twice as many sharks in the seas then as exist today. Melville had gone to sea on a whaling ship himself, so he understood the sailors' perspective, their loathing for sharks as dangerous pests and competitors. He devotes a chapter of *Moby-Dick* to 'The Shark Massacre', which is not a massacre *by* sharks but *of* sharks by sailors, who defend their whale carcass overnight by using their highly sharpened whale harpoons to

'White Shark', woodblock from an instructive picture book of 1877.

White Shark

stab sharks through their cartilage skulls, hoisting them on deck to be skinned. These sailors disdained shark meat, tossing it overboard. Meanwhile Fleece, the African-American cook on board the *Pequod*, sermonizes about the sharks, objecting not to their scavenging nature or their devouring of the whale carcass, but to the noisy 'smacking of their lips' as they feed. Although Melville mentions the 'wondrous voracity' surrounding the whale carcass, his metaphor for the feeding event is hardly respectful: 'Any man unaccustomed to such sights, to have looked over her [the ship's] side that night, would have almost thought the whole round sea was one huge cheese, and those sharks the maggots on it.'[1] Sharks are either reproached for their poor table manners or compared to insects that live on carrion and rotting things.

Only the white shark receives more respectful depiction – and only in the service of a much larger metaphor, whiteness, which is aligned with haunting and evil, at least in animals. 'As for the white shark, the white gliding ghostliness of repose in that creature, when beheld in ordinary moods, strangely tallies with the same quality in the Polar quadruped [the polar bear, another powerful carnivore] . . . Witness the white bear of the poles, and the white shark of the tropics; what but their smooth, flaky whiteness makes them the transcendent horrors they are?'[2] Moby-Dick is, of course, the white whale, an albino sperm whale of famous ferocity, elevated to the status of myth and endowed with powers so mysterious as to be possibly supernatural. He can, for instance, lift his head out of the water to scan the surface – an ability that white sharks use routinely. The white whale also rams the *Pequod* and sinks her, as white sharks have been known to do with much smaller fishing boats off Maine and the Canadian Maritimes. Once hunted, Moby-Dick returns the vengefulness and becomes the hunter, not

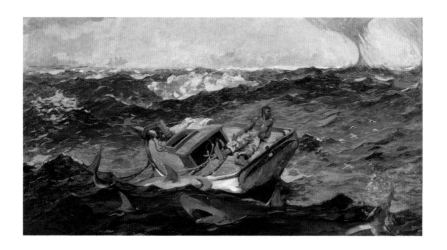

unlike Peter Benchley's later mythical beast, with both captains, Ahab and Quint, acting out their vendettas.

Interestingly, in both novels it's the combination of greed and obsession that results in the final encounters and the captains' deaths. In *Moby-Dick* the avarice of the ship owners is lavishly depicted in the ever-tinier percentages of the voyage's profit allotted to everyone but themselves. In *Jaws* all but the first fatality could have been avoided if the mayor and merchants of the resort town had risked losing tourist dollars by posting shark warnings and keeping swimmers out of the water. Melville's great story depicts the exploitation of nature, seen as a limitless resource. He shows human hubris both in the owners' eager use of others – including not only their time and toil but their safety – and in the passionate, selfish obsession of Captain Ahab with killing the white whale and thus avenging the loss of his leg. What Ahab misses is not so much his leg, or the lives of his crewmen, as his secure sense of superiority, his belief in his dominance over all other creatures. Moby-Dick got the better of

74

him. Benchley's Quint also asserts his superiority over 'any fish'. And while he holds no grudge against this particular rogue shark, he carries a fear and loathing of the genus as a whole. Quint eventually reveals that he was a survivor of the sinking of the USS *Indianapolis*. After seeing his shipmates butchered by sharks, he's spent the 30 intervening years looking for opportunities to even the score. The two captains' obsessions are thus defined by their centuries, although the effects are the same from nature's point of view: our species killing and exploiting the creatures of the oceans for both pride and greed.

In terms of sensationalism and destruction of species, nothing rivals *Jaws*, particularly as those who missed the book could catch the movie. The Benchley novel was the beach-book bestseller of 1974, scaring tens of thousands of people out of the water. The Spielberg movie terrorized many millions more from the summer of 1975. As Peter Benchley protested near the end of his life, after he'd become a marine conservationist, *Jaws* was 'just fiction, a novel, and [he took] no more responsibility for the fear of sharks than Mario Puzo took responsibility for the Mafia'.[3] Yet *Jaws* touched a nerve, evoking deeper fears and inciting an extraordinary response. It is no exaggeration to say that *Jaws* launched a thousand ships, or at least a thousand charter fishing boats, all of them gunning (sometimes literally) for great white sharks. Shark-fishing tournaments sprang up. Charter boat captains like Frank Mundus, the model for Quint, saw their bookings explode. Professionals such as Mundus and the Australian 'greats' Alf Dean and Vic Hislop had for years been staking their reputations on killing the largest sharks; the *Jaws* hysteria inspired the amateurs. Unfortunately, this inspiration – whether a morbid fascination or a desire to assert mastery – took the form of catching, killing and then being photographed beside the open mouths of huge sharks, not viewing them in the wild.

The characters in both versions of *Jaws* are strictly stock: the shark hunter Quint, an antisocial hero; the clever scientist; the police chief who is so much an urban transplant that he can't swim; and the upright mayor. The cast of victims includes the innocent boy and the unfortunate teenager, paralleling the fatalities of the Matawan shark or sharks, and the girl who thrills us with her various acts of daring, going off into the dunes with a boy and deciding to take a midnight swim, solo and naked, out to an offshore buoy. According to the unwritten rules of the gothic genre, we can expect the wild, possibly wanton young woman to be a victim, and indeed she is, but Spielberg ingeniously makes us fond of her first. Chrissie is very much alive. Her male companion is too drunk to be useful, or to swim. And she's unafraid, unashamed and beautiful, not to mention an expert swimmer – none of which can help her against the immense power and ferocity of the shark. The initial victim in the Benchley novel is a less attractive character: an anonymous scuba diver who is killed quickly and never knows

M. Dubourg,
Killing a Shark,
1813, print.

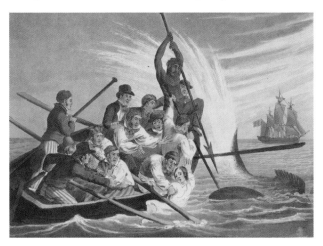

what hit him. What hit him is a huge female shark, ravenous and indiscriminate enough to eat him because she's pregnant. Benchley's diver is a purely random casualty, depicted with neither personality nor face, someone who arouses little sympathy. The horrifying and protracted savaging of Spielberg's lovely young woman makes the shark a monster of a different order, one without apparent reason for its hunger, a malicious force. While both the movie and the book versions of *Jaws* owe considerable debt to Melville, Spielberg's is greater since his shark is the more mysterious monster, a malevolent counterforce to our own species. Whereas in Benchley's *Jaws* nature strikes back unwittingly, Spielberg's shark, like Melville's white whale, appears to operate with a motive at least as methodical as Ahab's madness.

The great white shark in *Jaws* the movie is destroyed by a fortuitous combination of good marksmanship and elementary knowledge of physics. That is, the police chief gets off a well-planned but lucky shot that ignites the oxygen bottle lodged in the shark's mouth, thereby blowing the shark's head off. Here's a plot point that a teenage boy would love. We tend to accept this combination of firearms, gore and implausibility in big-budget Hollywood films. And yet the same elements come together in Ernest Hemingway's *Islands in the Stream*. The protagonist, a distinguished American painter named Thomas Hudson, is fishing off Bimini with his sons and his favourite deckhand, an old rummy named Eddie. The two teenage boys are spear fishing in the Gulf Stream when a huge hammerhead shark arrows towards the boy with a fish on his spear. Hudson, in what passes for fatherly responsibility, has positioned himself on the bridge with a .256 Mannlicher Shoenauer, an elephant gun, but is unable to stop the determined shark. Fortunately, the shark is on the surface, charging much like a

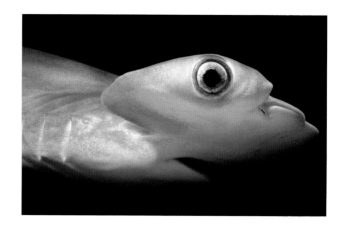

Caribbean Scalloped hammerhead shark head portrait (*Sphyrna lewini*) Kanohe Bay, Hawai'i.

rhino or an African buffalo, rather than attacking from below as tiger sharks, white sharks and makos are likely to do. Hudson has time to exhaust his magazine, after which Eddie has time to go below deck and retrieve his submachine gun from a trunk beneath his bunk. It's lucky he keeps it loaded!

Hudson was trying . . . not to think of anything but the shot; to squeeze and keep just a touch ahead and at the base of the fin . . . when he heard the submachine gun start firing from the stern and saw water start to spout all around the fin . . . As he shot, the clatter came again, short and tight, and the fin went under and there was a boil in the water and then the biggest hammerhead he had ever seen rose white-bellied out of the sea and began to plane off the water crazily, on his back, throwing water like an aquaplane. His belly was shining an obscene white, his yard-wide mouth like a turned-up grin, the great horns of his head with the eyes on the end, spread wide out as he bounced and slid over the water, Eddie's

gun rapping and ripping into the white of his belly making black spots that were red before he turned and went down and Thomas Hudson could see him rolling over and over as he sank.[4]

The charge of the hammerhead is a minor event in *Islands in the Stream*. Sharks, particularly the elemental mako shark, loom much larger in *The Old Man and the Sea*. Unlike in *Islands in the Stream* or Peter Benchley's novels, the mako in Hemingway's 1952 classic is more than a crude device to inflame the action; in fact, the shark is accurately described, and with respect. Santiago, the old Cuban fisherman, has captured a very beautiful marlin, so large that he can't bring the fish aboard but has to lash it to his boat where it's vulnerable. Attracted by the smell, the mako comes up from the depths, picks up the scent and approaches rapidly.

He was a very big Mako shark built to swim as fast as the fastest fish in the sea and everything about him was beautiful except his jaws. His back was as blue as a sword fish's and his belly was silver and his hide was smooth and handsome. He was built as a sword fish except for his huge jaws which were tight shut now as he swam fast, just under the surface with his high dorsal fin knifing through the water without wavering. Inside the closed double lip of his jaws all of his eight rows of teeth were slanted inwards. They were not the ordinary pyramid-shaped teeth of most sharks. They were shaped like a man's fingers when they crisped like claws. They . . . had razor-sharp cutting edges on both sides . . . Now he speeded up as he smelled the fresher scent and his blue dorsal fin cut the water.[5]

Another American author who writes well about sharks is Robert Stone in *A Flag for Sunrise*. His protagonist, a middle-aged expatriate with more intelligence than purpose, finds himself in Belize, where he takes a day to go scuba-diving. Stone describes the effects of nitrogen narcosis, 'the rapture of the deep', which can indeed cause euphoria in its early stages, a feeling of well-being in the presence of something sublime. Stone's character follows the coral beds deeper. He is foolish enough to be diving solo.

> On the next terrace he saw the black coral. There seemed to be acres of it, dappled with encrusting yellow infant sponges, and circling down he felt as though he were flying over a lava field grown with daisies. When he got closer, he could see the coral's root and branch patterns. It was sublime, he thought. He could feel his heart beating faster; his blood coursing through him like a drug. The icy, fragile beauty was beyond the competency of any man's hand, even beyond man's imagining. Yet it seemed to him its perfection provoked a recognition. The recognition of what? he wondered. A thing lost or forgotten. He followed the slope of the coral field. Down.[6]

Tempted deeper by the effects of beauty and narcosis, the diver notices shimmers of light that he identifies as schools of fish in flight. Bonitos are also racing up over the drop. As his rapture tips into anxiety, then panic, he imagines that the ocean itself has begun to tremble, that the smallest reef fish are 'quivering like mobile sculpture . . . Around him the fish held their places, fluttering, coiled for flight.' What the diver conjures, the conclusion that he suspects then determines must be true, is something has startled the fish into panic, that the reef creatures sense the monster's presence without sight of it.

It's out there. Fear overcame him; a chemical taste, a
cold stone in the heart . . . As he peddled up the wall,
he was acutely aware of being the only creature on the
reef that moved with purpose. The thing out there
must be feeling him, he thought, sensing the lateral
vibrations of his climb, its dim primal brain registering
disorder in his motion and making the calculation.
Fear. Prey.[7]

Only when he reaches the surface does Stone's character put a
name to his fear. 'A big shark maybe',[8] which has also been the
reader's apprehension and dramatic hope: the bigger, the bet-
ter; and a truly dangerous species with a telltale rounded dor-
sal or white belly or tiger stripes, even better. The Belizean
divemaster corrects him: 'Don' be saying shark if you don' see
one,'[9] and the reader also feels the rectitude of this correction.
Don't cry shark, don't cry wolf, don't displace your nameless
terrors on a fish, particularly if you haven't even seen it.
Stone's character is under the influence of a narcotic not only
when he feels the rapture but also when his fear accelerates
into panic, an imagined awareness of the shark as the agent of
his fate. He thrills equally in terror and in ecstasy.

Although Edgar Allan Poe was neither a seafarer nor a real-
ist writer, the sharks depicted in *The Narrative of A. Gordon Pym*
are not magnified or misrepresented. They accompany the
ship as sharks will, if only because the ship is trailing the oil
from dead turtles and other foodstuffs. They keep the men
from bathing in the ocean. They add to the general misery and
dread of the surviving crewmen short on water and suffering
from heat. Even when the ship founders, tossing the men into
the sea with the huge sharks, they do not attack. Thus Poe the
fabulist becomes the realist after all.

Shark depictions in films are not only sensational but nearly always silly. Spielberg's Moby-Dick monster is among the most accurate, with the *Jaws* sequels and *Jaws* imitations ranging well below the original in both production values and regard for what we know about sharks. Spielberg's mechanical monster at least looks like a white shark (even if its caudal fin never breaks the surface). The *Jaws* production also took the time and trouble to film actual white sharks at Dangerous Reef, off South Australia, with the help of renowned shark experts and underwater photographers Ron and Valerie Taylor. Marine scientists and divers – really anyone with knowledge of shark behaviour – doubt the premise of the rogue shark, but the script's exaggerations seem reasonable compared to the absurdities of the *Jaws* sequels.

Jaws 2 is a less convincing account of the same events: same police chief, same place, same shark. *Jaws 3D* offers not one but two white sharks that have managed to sneak into a Marineland park where they hide when not eating tourists and staff; some of the footage uses not a *Carcharodon carcharias* but a nurse shark. *Jaws – The Revenge* is the worst, its premise being that the shark, somehow related to the fish killed by the original Chief Brody, seeks vengeance on the entire Brody family, following Mrs Brody down to the Bahamas after eating her son. The avenging shark is not only endowed with the ability to swim at supersonic speeds but is shown to possess that most peculiarly human obsession, the family vendetta.

Ironically, one of the best of the genre – at least from a shark-lover's perspective – dates from this era of ludicrous *Jaws* retreads, the 1970s, and uses the Jaws name. *Jaws of Death* (1976) is much less dreadful than its title suggests. The protagonist, Sonny, has been given a charm by a Philippine shaman allowing him to charm sharks. He scuba-dives out to shark-fishing boats where he kills the shark killers and feeds them to his

friends, the sharks. Eventually, there arrive the inevitable cruel scientist and the unscrupulous, greedy businessman, at which point Sonny develops a more psychopathic side. However, the actual shark footage is excellent, even if it appears that several real tiger sharks must have died in the filming.

The contents of many of the shark-ploitation movies can be inferred from their titles: *Blood Surf*, *Red Water*, *Megalodon*, *Night of the Sharks*, *Shark Zone*, *Raging Sharks*, *Shark Attack*, *Shark Attack 2* (sharks on steroids – they growl), *Shark Attack 3: Megalodon*, *She Gods of Shark Reef* and *Spring Break Shark Attacks*, in which bikini-clad college babes vacationing in Florida are terrorized by tiger sharks lured towards shore by an unscrupulous, greedy businessman hoping to gain an edge in the resort hotel market. One film that stands out in this B-movie category is *Blue Demon* (2005). The premise of the film is, on its surface, absurd: scientists under contract to the US Defense Department have implanted computer chips into the brains of genetically modified sharks to use them as weapons against terrorists and to guard the coasts of the United States against infiltrators. Naturally, the sharks run amok. The movie begins with the courage of its apparently laughable convictions, then veers toward the more inane James Bond pictures, with a crazed Air Force general and a midget villain, remote explosions that make little sense and plastic dorsal fins. And yet, this ludicrous, half-hearted movie turns out to be based on an actual programme. According to *New Scientist* magazine, the Defense Advanced Research Projects Agency (DARPA), an arm of the Defense Department, has been financing research on how to insert neural implants into the brains of sharks 'in hopes, one day, of controlling the animal's movements, and perhaps even decoding what it is feeling'.[10] Researchers hope to 'exploit sharks' natural ability to glide quietly through the water, sense

delicate electrical gradients and follow chemical trails. By remotely guiding the sharks' movements, they hope to transform the animals into stealth spies, perhaps capable of following vessels without being spotted.' At the time of the article, March 2006, research scientists had advanced only as far up the evolutionary ladder as the primitive dogfish, but DARPA planned to extend their 'steering' to blue sharks, which grow to almost four metres. According to project engineer Walter Gomes of the Naval Undersea Warfare Center in Newport, Rhode Island, a team will soon be placing neural implants into blue sharks and releasing them into the ocean off the coast of Florida.[11] Improbable as this project may sound, we should remember that the US Navy trained bottlenose dolphins as sentries and operationally deployed them in South Vietnam in 1971.

This project is not the first time the military has invested in shark technology. Noah Shachtman of DefenseTech.org claims that 'the Navy has tapped three firms to build prototype gadgets that duplicate what sharks do naturally: find prey from the electric fields they emit'. One of them, Advanced Ceramics Research, Inc., describes the project's potential benefits this way: 'If developed, such a capability might allow for the detection of small, hostile submarines entering a seawater inlet, harbor or channel, or allow objects such as mines to be pinpointed in shallow waters where sonar imaging is severely compromised.'[12] And then there's that ultimate underwater dream, the Microfabricated Biomimetic Artificial Gill System, which must be left up to readers' imaginations since the programme is classified as 'top secret'.

Such Defense Department projects seem ridiculous even by the standards of a James Bond movie. In fact, the Bond movies are both more moderate in their imagined uses for sharks and

wittier about how seriously to take themselves. Sharks are props, or part of the dangerous *donnée*. In *Live or Let Die* Bond and his gorgeous female companion are bound together, dangling from a winch above the water in an island cave. The blood dripping from Bond's wounds provokes the inevitable man-eating sharks. They thrash, snapping at each other, at which point the winch begins to descend. In *For Your Eyes Only* Bond and another beautiful woman are tied together, but this time at the end of a rope attached to a speedboat, about to be dragged over very sharp coral. They will inevitably be ripped to shreds and bleed into shark-infested water. Cut to an underwater shot of reef sharks looking agitated, possibly eager, as though they know what to expect (have they read the script?) The most memorable of the shark props is the shark pool in *Thunderball*. James Bond is fighting a minor villain in a swimming pool when a metal sheet rolls over the surface of the pool and several large, scary-looking sharks enter through an underwater hatch. Luckily, Bond has been issued a clever breathing gadget by Q, the tech wizard for the British Secret Service, and he's able to drown his opponent and wait patiently until the last killer shark has swum into the pool before escaping through the hatch. Leaving aside the implicit message that sharks are always poised to attack, particularly when there's blood in the water, the malevolence in Bond movies always has a human source. Sharks will be sharks, but we know who the real monsters are.

The one accurate shark film, its realism a disappointment to some audiences, is the low-budget *Open Water* (2003). The sharks are real and really circling in close proximity to the actors; they're also relatively small. Filmed in the Bahamas, where moderate-sized dusky, lemon and blue sharks are common, *Open Water* is based on an actual occurrence – a couple of honeymooners who were inadvertently left behind by their dive

boat on Australia's Great Barrier Reef. The dive operation only realized their mistake many hours later, leaving the couple abandoned and floating in open ocean for about eighteen hours before searchers reached the location of their dive. The currents had swept them many hours away by that time. Their bodies were never recovered, but their equipment, including their dive vests, was washed ashore. The conclusion that many experts reached was that the couple removed their buoyant dive vests and elected to drown. What makes *Open Water* powerful, as well as less than fun, is that it takes an actual event, a common and realistic fear among divers, and plays it out to the end. After their dive, the honeymooners rise to the surface only to find an empty ocean. Their boat has left without them. They do everything they should in order to stay warm and be discovered. Sharks discover them and circle, with a greater number circling below the surface than with fins showing. This detail is accurate, as is the fact that the sharks bump but don't bite until one of the victims falls so deeply asleep that he fails to react to a bump. Even then, the wound is minor. Only when the man dies from exposure, is released from his dive vest and sinks does any predation occur. The woman elects to remove her vest and drown rather than face a slow, fearful, painful death. Given the standard features of the genre and the pressures of an audience accustomed to the thrills of gore and terror, *Open Water* is a marvel of integrity, pandering less than many documentaries. It shows that real sharks are less dramatic than those of our imaginations. Sharks very rarely eat people and never develop vendettas against resort communities or families.

Although many of the Discovery Channel's productions – *Anatomy of a Shark Bite* (2005), *Great White Death* (1981) or *Operation Shark Attack, Volume 4* (1998) – feed on the same sensationalism as fictional shark films, it's heartening to note how

much more accurate, informative and grown-up shark documentaries have become over the last 25 years. After starting with the obligatory footage of a great white, *The Secret Life of Sharks and Rays* focuses on much smaller fry, including cat sharks, nurse sharks mating, a saw shark hunting and a horn shark being swallowed by an angel shark. In the Nature series, *White Shark/Red Triangle* uses our common infatuation with the fiercest predators to direct our curiosity towards such interesting scientific questions as the relationship between shark populations and expanding pinniped (seal and sea lion) colonies and the correlation between shark attacks on surfers and the introduction of the shorter, sea-lion-sized surfboard. While we might wonder whether audiences have to be baited with dramatic footage before they'll view, then appreciate, the less dangerous shark species, we can be grateful for the sophistication and intelligence of more recent documentaries.

Something of the same process has worked for Damien Hirst, whose fame increased enormously after the creation of his installation with a four-metre tiger shark, *The Physical Impossibility of Death in the Mind of Someone Living* (1991). Here the physical object is the sensational part, since this sculpture is an actual shark suspended in a glass tank filled with formaldehyde. Hirst grew up a passionate fan of punk rock, in particular the Sex Pistols. His art was already sensorily challenging and death-obsessed before he acquired a shark. It was Hirst's *A Thousand Years*, consisting of a large glass case in two sections containing a cow head being eaten by flies and maggots, that first attracted the attention of Charles Saatchi. Saatchi had been the advertising man for Prime Minister Margaret Thatcher before opening his avant-garde gallery, and he recognized the advantages of bold presentation. Saatchi funded *The Physical Impossibility of Death in the Mind of Someone Living* (at the cost

of US$50,000) and, in 1992, organized the Saatchi Gallery British Young Artists show at which Hirst's tiger shark and cow head were displayed. The rest is art history. Hirst won the prestigious Turner Prize (for another work) in 1995 and sold his iconic *The Physical Impossibility of Death in the Mind of Someone Living* to American hedge fund billionaire Steven A. Cohen for $8 million; he reportedly sold a second, much smaller tiger shark in formaldehyde to a South Korean dealer for $5.7 million.[13] Hirst's explanation, 'I grew up in the generation of *Jaws*. I knew it was the piece of the 90s',[14] prompts the question of where his career and net worth would be without sharks.

Brilliant sensationalism makes a place for itself in art. In his interview book, *On the Way to Work*, Hirst says, 'I like creating emotions scientifically.'[15] Such is the calculating genius of not only Spielberg but Hitchcock and Kubrick. Whether the material subject is sharks, birds or ghosts, the creature is never the real subject. Reviewer Felix Salmon described his response to Hirst's shark at the 1992 Saatchi show:

> Meanwhile, the shark was suspended in formaldehyde, sleek, deadly, and – of course – dead. It didn't look dead, though; it looked as though it was alive . . . Walking around it, staring at it staring at you, you felt an undeniable frisson of real physical danger. The shark delivered an atavistic shock, catapulting the viewer back to our Darwinian past even as we stood admiring its artistry. Much great art works by setting up an ironic tension between the art and the object: are you looking at brush strokes, or are you looking at what they represent? . . . The shark was the art, of course; but the art also consisted in the primal reaction to it – a reaction over which any human had almost no control.[16]

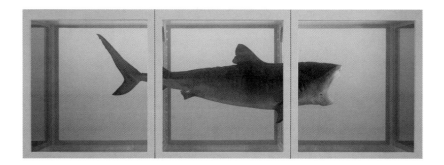

Unlike his other works, which feature the carcasses of docile animals, Hirst's tiger shark evokes the threat of death, the floating shark being the potential agent of fate, rather than depicting the processes of post-mortem decomposition so evident in his cow-head sculpture, *A Thousand Years*. Hirst's famous lamb (*Away from the Flock*) and dog (*In His Infinite Wisdom*) in their formaldehyde-filled glass cases may look lifelike in death but hold no possibility of death in their teeth. His sharks are different not in their presentation – all his animals are real, preserved for as long as their pickling agents will last – but in the sensational place they occupy in the audience's imagination. Hirst's methods of 'creating emotions scientifically' are shock and calculation. In the Guardian, art critic Jonathan Jones describes Hirst and the Young British Artists:

> Death, decay, the sublime were the themes of the British art that defined the end of the 20th century; the horror of the shark swimming towards you through formaldehyde … The sublime was the aesthetic of these years, this art – and the sublime, as the 18th century politician and thinker Edmund Burke argued, is about power. The origin of the sublime, for him, lies in our awe before a majestic,

Damien Hirst, *The Physical Impossibility of Death in the Mind of Someone Living*, 1991, mixed media including preserved shark.

divine authority. Today it is an awe of art itself, or at least a desire to experience that awe; to be knocked over by art, to be kicked in the teeth.[17]

What sets Hirst's shark apart from his other animals is the danger it projects. Without this threat, we feel no awe, only guilt and shock at the carnage.

Hirst seeks a direct connection to the public and tries to evoke a visceral response.[18] Perhaps he regrets our treatment of lambs and cows. But his sympathy does not seem to extend to sharks: after a period of some obfuscation, it has been revealed that Hirst's shark supplier is Vic Hislop, the world's most notorious shark hunter. Hirst bought his original tiger shark from Hislop for $10,000.[19] He has since purchased three more from him: two freshly caught tiger sharks along with a great white that Hislop said he had in the freezer. The 1.5-metre tiger shark that Hirst sold to the South Korean dealer for more than $5 million was something that Hislop had tossed in as a 'freebie'.

Damien Hirst and newly repaired shark.

Asked whether Hirst wasn't self-franchising or profiteering from his old inspirations, Hirst's manager, Frank Dunphy replied, 'Look, Damien likes doing sharks.'[20]

Whereas Hirst's shark sculpture, being an actual tiger shark, is – narrowly defined – realism, John Singleton Copley's *Watson and the Shark* (1778) depicts one of the least anatomically accurate sharks in art. This shark has shapely lips, whose light brown shade sets them off nicely from the pretty teal of the animal's smooth skin. Small as it is, the shark's eye seems interested, neither cold nor alien. Approaching a naked, prostrate boy, this lovely-lipped shark seems sexualized, particularly as the boy's wounds are so discreetly placed as to be invisible. Copley's depiction was based on a real event that occurred in Havana Bay in 1749, when Brook Watson, a fourteen-year-old boy serving as a merchant seaman, took a solo swim and was attacked by a shark. In the first assault, the shark stripped the flesh from the boy's leg. In the second attack, it bit off Watson's foot. Looking closely with these facts in mind, we can see some reddish cloudiness in the water around the spot where the figure's right foot would be if it didn't disappear into the base of the painting. At the time of the attack, Watson's shipmates were waiting with a boat to take the captain to shore, so they were able to respond quickly and rescue him. In the painting they present a tableau of dread and helpfulness, two reaching out to save the boy, one keeping the more daring reacher from falling overboard, one ready with a rope, one about to stab the shark with a boat hook,[21] and four others looking on with earnest concern. Every figure, especially the shark, is caught mid-action. Shark attacks do indeed inspire our communal heroics and concern, as well as our sense of drama. Certainly Copley was inspired by his subject, even if he had never visited Cuba or seen a shark.

The painting was probably commissioned by Watson. We know that Copley interviewed Watson: his diary includes a reference to a dinner engagement with him in 1774.[22] When the painting was first exhibited at the Royal Academy, London in 1778, a detailed description of the attack was published in a London newspaper. This description, believed to have been written by Brook Watson himself, spares its readers none of the gory details – rather it thrills to them – but ends by assuring its audience that 'after suffering an amputation of the limb, a little below the knee, the youth received a perfect cure in about three months'.[23] Watson went on to become Lord Mayor of London. Thanks in part to Watson, the shark and his own sense of drama, Copley went on to achieve his own fame and celebration.

At least in location and inclusion of boat and sharks, Winslow Homer's *Gulf Stream* (1899) alludes to *Watson and the Shark*, perhaps gently correcting it. Brook Watson's loss of a foot to a shark in Havana Bay was a freakish event. Sailors in small boats struggling against waves and exposure – with the presence of sharks and bad weather also part of the package – was (and is) a far more usual occurrence. So is the fact that Homer's stranded boatman is black. This sailor in his small de-masted boat is in a dire situation, threatened in numerous ways – by the ocean swells, by the sharks, by that waterspout in the distance, by his apparent lack of shelter, by his aloneness. Whereas Watson enjoys the attentions of a boatload of rescuers and is in any event surrounded by ships and wharves, Homer's sailor is on his own, lost at sea, carried by the winds and currents and vulnerable to whatever nature sends his way. Our eyes may go first to those large, lolling sharks but, considering the sailor's predicament, they're the least of his worries. Those sharks won't get him unless something else – being capsized by a wave, being overturned by a waterspout or despair at his hopeless position – lands him in the water first.

Another way in which Homer has the edge on Copley is the accuracy of the shark depiction. Homer's sharks are accurate by any measure, not only anatomically convincing and correct, but behaviourally realistic as well. His sharks circle lazily, showing both their distinctive dorsal fins and their less usually depicted caudal fins. They gape and loll. Copley's shark is so inaccurate as to suggest that it was drawn from imagination. Homer's could have been drawn from life. What's more, Homer considered the other dangers facing the solo sailor lost at sea. His sailor is probably doomed, but not

The abdominal organs and eggs of a shark, illustration from *Hieronymi Fabricii ab Aquapendente: Tractatus quatuor* (Frankfurt, 1624).

by the presence of sharks. His being so alone makes his death inevitable.

Early naturalists worked from secondary sources, both for their illustrations and their descriptions. The great French naturalist and illustrator George-Louis Leclerc, Comte de Buffon (1707–1788) rarely left his home. Nevertheless, he achieved both an accuracy and a freedom from fabulation not achieved by the earlier, sixteenth-century naturalists Ulisse Aldrovandi and Konrad Gesner. Aldrovandi drew lovely illustrations but displayed what Comte de Buffon called a tendency to credulity. Writing about stingrays, Aldrovandi noted that 'they love music, the dance, and witty remarks'.[24] The Swiss naturalist Konrad Gesner was less fanciful, at least in his descriptions of 'dogfish' and 'seadogs', although he included drawings and descriptions of various dragon-like sea monsters among his fish. Gesner distinguishes between different species of 'star

George-Louis Leclerc, Comte de Buffon, hand-coloured engraving for his *Natural History* (1821).

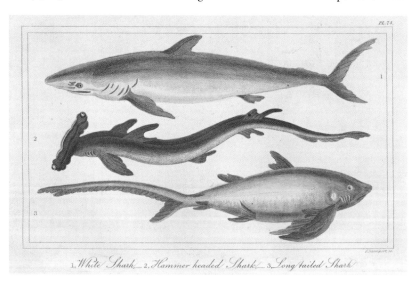

1. White Shark, 2. Hammer headed Shark, 3. Long tailed Shark

White shark tooth and hammerhead shark, illustrations from Konrad Gesner, *Historia Animalium* (Zürich, 1575).

Hammerhead shark, in Willem Piso, *Gulielmi Pisonis . . . De Indiae utriusque re naturali et medica libri quatuordecim: quorum contenta pagina sequens exhibet . . .* (Amsterdam, 1658).

dogs' or 'star dogfish' based on the star-shaped specks on their skin and the taste of their meat, and he offers a good description of the 'bluedog' or blue shark. Of the 'sledgedog' he writes:

> This fish has a head formed like a sledge of hammer, from which he gets his name in all nations. Underneath he has a broad mouth and many strong and sharp teeth, with a wide tongue like a person's. His back is black and stomach white, and he is very terrible and beastly to behold . . . This fish shall be a very large, beastly and terrible animal, which never goes to shore because there it could catch only small prey. It eats all kinds of fish, and will also swallow and tear apart swimming people. When sighted, it is considered a sign of hateful bad luck.[25]

Fisherman saving a child from the jaws of a shark. Engraving by Castelli (1878).

Gesner refers often in his dogfish and seadog entries to the authority of Pliny's and Aristotle's accounts, some 1,500 years before; he evidently saw them as his immediate predecessors. What's also striking is the tendency in both Aldrovandi and Gesner to a sixteenth-century sensationalism. Aldrovandi has a whole volume on sea monsters. Gesner is more sparing in his descriptions of sailor's imaginings, but he reports that the spines of certain sharks are deadly poison, that hammerheads are not only bad tasting but rapacious and that blue sharks swallow their young and then (usually) spit them out again. Many of his descriptions seem intended less to transmit knowledge than to feed the imagination.

Many titles on sharks can be found under the heading 'children's' in book shops. Even among novels, movies and artistic representations aimed at adults, depictions of sharks are frequently not only exploitative and sensational but evince 'a tendency to credulity'. This willingness to believe the fantastic worst about sharks is therefore one way one way to separate the men from the boys (or, in Hemingway's case, his best work from his boyish self-imitations). Although we may never entirely escape the ways that our era's cultural lens shapes our perceptions of sharks, we can at least try to observe them in their own terms, rather than as monsters of our myths and imaginations.

Girls in boat attacked by 'Sharks in the Adriatic'; an engraving from *Le Petit Journal* (1908).

4 Unscrupulous Lawyers and Other Predators

The most ruthlessly ambitious among us are so frequently referred to as 'sharks' that the term has become synonymous with unscrupulous lawyers and predatory business practices. What's the harm? Sharks are unlikely to form an anti-defamation league. But demonizing sharks is more than a case of the pot calling the kettle black – or, in this case, bloodthirsty. Humans are capable of being far crueller, both quantitatively and qualitatively, than sharks. Would a shark kill for some weird sexual fetish, or just for the fun of it? No species is as destructive or as vicious in pursuit of its desires as our own, so it's ironic how routinely we connect sharks with our most reviled human traits.

Even the etymologies of the word 'shark' could be considered defamatory. According to the website www.shark-info.com, the Anglo-Saxon root is *scheron*, a corruption of the French *arracher*, meaning 'to snatch or tear'. Neat as this theory might seem, it is not generally considered to be the real etymology of the word. Some scholars think 'shark' may have come from the German *schurke*, meaning 'villainous person'.[1] The *Oxford English Dictionary* judiciously declares the origins obscure, citing the first known usage as 1569 when the sailors on John Hawkins' expedition to the western Caribbean returned with a specimen they called a 'shark'. Since the sailors were in contact with local

Indians, this 1569 usage probably derives from the Mayan word for shark, *xoc*, pronounced like 'shawk' or 'shock'. Previously, sharks had been referred to as 'sea dogs', or known by the Spanish name *Tiburon*, a word adopted from the Carib Indians.

William MacGillivray, *Nursehound and Spurdog:* Scyliorhinus stellaris *and* Squalus acanthias, 1831–41.

However, an alternative etymology presented by the OED is that 'shark' derives from *shirk* which comes from *schurke*.[2] In old usage, *shirk* was a noun referring to someone who was not only indolent, a task avoider, but a parasite and a scoundrel preying on others. A 'sharp', later a 'sharpie', also comes from *shirk*, and here the words – if not their derivations – converge. Whether shark comes from *schurke* remains in doubt, but we know that 'card shark' and 'pool shark' are recent corruptions of 'card sharp' and 'pool sharp', *sharp* referring to the scoundrel who preys on the unsuspecting. Therefore, sharks might conclude that our species has unfairly maligned theirs by projecting our own villainous and despicable traits on them, if not in original

Antoine Berjon, *Still Life with Flowers, Shells, a Shark's Head, and Petrifications*, 1819, oil on canvas.

etymology, then in recent corruptions. Furthermore, our species could be seen as the sole perpetrator of this defamation, entirely responsible for the irreparable harm inflicted on unfortunate sharks, both in reputation and in their rights to habitat, even in their right to live, by our projection of our own heinous qualities on to them. At least that's the way the legal argument might be made by a shark.

The joke asks, 'Why don't sharks attack lawyers?' The answer is, 'Professional courtesy'. The mechanical shark in *Jaws* was nicknamed 'Bruce' by the film crew because Bruce was the name of Spielberg's lawyer. Sharks have so often been used as symbols for lawyers that an American television series about an unscrupulous lawyer is entitled simply *Shark*. The ever-avid James Woods plays Sebastian Stark, a cut-throat attorney whom everyone calls 'Shark'. In each episode he tries something so devious and underhand that he risks his career, but one way or another he always gets away with it. Sharks will be sharks. That is, sharks will be malicious, unethical, dishonest and greedy.

Another long-reviled figure is the usurer, more recently known as the 'loan shark'. 'Shark' here is no corruption of 'sharp' or 'sharpie', but refers to a predatory moneylender who offers short-term unsecured loans at exorbitant interest rates, if necessary backed up by blackmail or threats of violence. (Interestingly, the Japanese term for such extra-legal lenders,

Lawyer shark cartoon.

'Congratulations Mr Smith – as soon as I saw you I knew that you were the right man for the job'

yamikinyu, also means 'loan shark'.[3]) The name conjures images of someone prowling around seeking out the vulnerable fluttering in their desperation, homing in on them as a shark would on a naïve or wounded fish. But the analogy between usurers and sharks is limited: the human version *chooses* to be a loan shark rather than, say, a charity worker. The shark has no choice but to be a shark.

The ultimate 'corporate shark' is played by Kevin Spacey in the film *Swimming With Sharks*, a 1994 satire about a movie mogul who abuses the vulnerable people working for him. The shark, Buddy Ackerman, subjects his staff to sadistic, public insults, assigns them meaningless errands, lies and dissembles,

Master Bertram (fl. 1367–d. 1414/5), *Creation of the Animals*, 1379–83, oil tempera on wood panel from the Grabow Altarpiece at the St Petri Church, Hamburg.

and generally tries to prevent his underlings from having any fun. He is not an isolated case. According to an *Ezine* article, 'Stress Management: Sharks and Dolphins at Work', the business world is divided into dolphins and sharks. Dolphins: 'They do what they say they will. You can confide in them. They are team players. Their behavior matches their words. They take responsibility for their mistakes. They can be trusted.' Sharks: 'They fail to follow through. You cannot confide in them. They're out for themselves. Their behavior does not match their words. They blame others. They cannot be trusted.'[4]

LAWYERS' CLUB

John Pritchett logo, 'Lawyers' Club'.

On the subject of sharks and dolphins, perhaps the most iconic satire of the public's shark fixation was 'The Landshark', a *Saturday Night Live* skit that originated in 1975. An obvious spoof of Spielberg's *Jaws*, which had come out earlier that year, 'The Landshark' featured the *Jaws* sinister approaching-shark soundtrack and a two-metre talking shark with Chevy Chase inside. According to the original script, 'the Landshark was considered the cleverest of all sharks. Unlike the great white shark, which tends to inhabit harbours and recreational beach areas, the Landshark might strike any place, any time. It is capable of disguising its voice, and generally preys on young, single women', persuading them to open their apartment doors, then dragging them into the hall and eating them.[5] The Landshark might pretend to be delivering a 'Candy-Gram'; it might pose as a plumber or even a dolphin.

> Lady: Who is it?
> Landshark: Plumber.
> Lady: I didn't hire a plumber. Who is it?!
> Landshark: Flowers.
> Lady: What . . . for who?
> Landshark: Plumber.

Lady: You're . . . that crazy shark, aren't you?

Landshark: No ma'am, I'm just a dolphin . . . Will you let me in please?

Lady: A dolphin! OK!

Silly as this skit may have been, it drew attention to two greater follies: first, the shark hysteria that swept the United States as a direct result of the film *Jaws*; and second, the replacement of a legitimate anxiety with a ludicrous one. Urban violence, particularly against young single women, was a genuine danger in American cities in the 1970s. The risk of shark attack has always been minute, particularly for those who never go beyond the surf, yet shark terrors were widely aired and discussed in the wake of the Spielberg movie. This echoes the media frenzy of 1916 following the so-called Matawan Shark attack, when public anxieties about the concurrent polio epidemic and horrifying European war were transferred to sharks.

Ron English, 'Night Sharks'.

Although the exploitation of sharks as ready symbols finds its most boisterous expression in the United States, this focus does have some legitimacy. The overwhelming majority of shark attacks occur in the US, as does most shark research. The American fixation with the shark as a powerful symbol is clearly reflected in the names of its submarines: the USS *Shark* (commissioned in 1936), the USS *Devilfish* (1943), the USS *Hammerhead* (also 1943), the nuclear sub USS *Shark* (1958) and the nuclear USS *Hammerhead* (1968). (The Germans, who have less of a maritime tradition, organized their U-boats into 'wolf packs'.) The use of shark names for submarines is understandable: sharks are well armed, fierce and merciless. They hunt by stealth and usually attack from below. And they never take prisoners. Divers who have been approached by a large shark in murky waters appreciate the submarine comparison best. The massive hull glides by, and if visibility is less than the length of the shark, you can't see the head and tail at the same time. Because the Japanese were thought to consider the shark a fearsome symbol, the Flying Tigers, a volunteer unit of American airmen fighting with the Chinese against Japan before the US entered World War II, painted not tigers but shark faces on their planes. In the cases of both submarines and fighter planes, the association with sharks was primitive symbolism, like a mask or a lion totem, intended to inspire the crews and to scare the enemy.

The song 'Mack the Knife' uses the shark as an ultimate reference point. Composed as 'Die Moritat von Mackie Messer' by Kurt Weill with lyrics by Bertolt Brecht for the *Threepenny Opera*, which premiered in Berlin in 1928, 'Mack the Knife' came to English-language fame after it was adapted by Louis Armstrong in 1956 and popularized by Bobby Darin in 1959. Weill's widow, Lotte Lenya, was in the studio when Armstrong

A US Army Signal Corps photograph of a Curtis P-40 fighter, one of the 'Flying Tigers', on the ground in Alaska, c. 1944.

made his recording, so he spontaneously added her name to the list of potential victims:

> Oh, the shark, has, such teeth, dear
> And he shows them pearly white
> Just a jackknife, has MacHeath, yeah
> And he keeps it, out of sight
> When the shark bites, with his teeth, dear
> Scarlet billows start to spread
> Fancy gloves, though, wears MacHeath, yeah
> So there's not a trace, hmmm of red . . .

'Fight the voraciousness of the capitalist monopolies that are ruining France. Support the Communist Party, party of the working class, the people and the nation', 1970, poster.

Sukey Tawdry, Jenny Diver, Lotte Lenya, Sweet Lucy
 Brown
Oh, the line forms on the right, dears
Now that Macky's back in town![6]

MacHeath is, of course, a psychopathic killer who far outstrips
the shark in terms of treachery and homicidal glee.

107

How have sharks earned their significant role in symbolism? Snakes, who kill tens of thousands of us annually, and piranhas, who hold a peculiarly vicious image for us, have never enjoyed the same cachet. Sharks can appear almost sexual. For a start, they are beautiful, many of them easily feminized in their slender shapes and sinuous movements. Others, such as white sharks or great hammerheads with their large and powerful dorsal fins, are readily cast as masculine figures. The attack on Chrissie, the young woman at the opening of Spielberg's *Jaws*, seems analogous to a sexual assault, particularly as the victim is naked. Indeed, the usual expression for a fatal shark attack in Africa, Australia and across the Pacific is that a person is 'taken', conjuring images of submission on the part of the victim. Fay Wray is 'taken' when she faints in King Kong's arms. The victims of vampires are 'taken'. Villagers are 'taken' in the night by tigers that raid their huts and drag them from their beds.

The violence associated with shark teeth in 'Mack the Knife' is sexualized, as is typical in the noir and horror genres. Beyond the crude appeal of sex and gore, we are fascinated by villainy, particularly of a single-minded, remorseless sort, and by the Devil and mythical monsters: the clay-eyed Golem; Medusa, whose very looks could kill; Dracula and the cast of vampires, so mercilessly *other* that they treat our species merely as prey. For all our tender sensibilities, we are drawn to the strange beauty of such appalling spectacle: the shark's pearly teeth, MacHeath's bright silver razor, the scarlet stain spreading below. We are transfixed whenever a shark appears – whether in literature, film, painting, song, formaldehyde or real life. Sharks hold such a sensational place in our imaginations that we have to wonder not only whether our responses to them might be primitive, but whether these responses could be so basic that they are wired to sexuality.

Herb Ritts, *Rachel with Shark*, 1989.

French School, *Deep Sea Diver with a Mermaid and a Shark* (oil on panel), mermaid representing Eros, greek god of love and diver representing Thanatos, greek god of death.

Freud has written that the uncanny (*das Unheimliche*) 'derives its terror not from something externally alien or unknown but – on the contrary – from something strangely familiar which defeats our efforts to separate ourselves from it'.[7] The terror is amplified or enriched from the recognition of something glimpsed in dreams or imagined from mythology: monsters from an inner abyss. Sharks and sea monsters, rising as they do from the deep, enjoy special symbolism in relation to the unconscious. If the abyss of the ocean symbolizes our own inner depths, then it would follow that the monster represents our repressed fears and desires. Freud goes on to define the uncanny as a subclass of terror, containing an element of the sublime –

Objects from Archduke Ferdinand II's 'Wunderkammer', including, on the ceiling, two sharks.

not just pleasurable but exalted. Our fear is mixed with awe before the spectacle of the great beast or monster, the experience even richer for being half anticipated or recognizable. Freud's theory, when applied to sharks, suggests that we fear them because we recognize some familiar outlines from our own depths.

The monster may also be said to embody sexual practices that are beyond the pale – not merely forbidden but unforgivable: murder, the 'taking' of another person into an oblivion from which there is no return. Within the category of human aberration, violent sexual predators are generally perceived as the most monstrous. Conversely, animal predators that are believed to prey on people become sexualized – not because of widespread repressed masochistic longings, but because of the associative pattern – huge, ferocious, overpowering, forbidden. We thrill to fear sharks not only because our own depths attract us, but also because we love our monsters, their power, their

Tzu Chen Chen, Eric Egron, and Dora Matlz, 'Requin farci' from *Une assiette poétique*, 2005, photograph.

familiar forms and their dynamism. As much as they may be objects of fear, sharks symbolize an aestheticized power greater than ourselves.

Like a divine being, the shark inspires fear and awe. It looms larger by its symbolism than its actual size, be it two, four or six metres. Underwater, everything appears 30 per cent bigger than it is, but the shark occupies an even larger space in the human mind. A popular expression comes to mind. 'Jumping the shark'

has its origins in American television but the term now has meaning even for those who missed the 1974 episode of the sitcom *Happy Days* from which it originated. In the original, inspirational scene, the Fonz, a character whom few would imagine getting his hair wet, is shown waterskiing. He then hurdles a shark. This episode occurred at a time when the show was seen as predictable and its market share was slipping. Thus, 'jumping the shark' has come to mean employing a truly ludicrous, farfetched plot or situation in a desperate attempt to get attention

'Air Jaws' in an Oxford house, sculpted by John Buckley.

or a larger share of the audience. Since the shark is sensational enough in its own right, *jumping it* must therefore be over the top, if not redundant. The expression is a testament to the shark as a sure-fire plot point and a symbol of attention-grabbing sensationalism. Whether for their misplaced symbolism or their wildly exaggerated reputation, sharks are always jumping themselves, introducing, through our perceptions, a spectacular element into every scene or situation they swim into.

Model shark outside a shopping-mall, Istanbul, Turkey, 2007.

5　No Adventure in the Fin Trade

The demonizing of sharks may be intriguing for what it projects about the human psyche, but it is highly dangerous to the world's sharks because it excuses, even ennobles, their slaughter. Biologists estimate that we kill 70 to 100 million sharks annually.[1] According to recent studies, including one published in *Nature* by a team of Canadian researchers,[2] the number of North Atlantic hammerheads is down by 89 per cent; thresher sharks by 80 per cent; white sharks by 79 per cent and tiger sharks by 65 per cent. Other shark species, including angel sharks (*Squatina squatina*) and gulper sharks (*Centrophorus granulosu*), are already extinct in large parts of their natural range.[3] The World Conservation Union's Red List of Endangered Species 2006 survey of 547 species of shark and ray identifies at least 20 per cent as threatened with extinction. Many sharks are killed inadvertently by large fishing operations, then discarded as waste. The meshing of beaches in Australia and South Africa and the use of drum lines to catch very large sharks result in the deaths of hundreds more sharks each year. These sharks are tabulated and sometimes dissected, then usually thrown away. Finned sharks – those with their fins sliced off – are dumped back into the sea to die.

Sharks have long been seen as loathsome and generally undesirable except for the commercial products they can provide – their skin, oil, meat and fins. Inflamed by legend and

Tiger shark (*Galeocerdo cuvieri*) caught in anti-shark net off Durban beach, South Africa.

sensational historical accounts, sailors were terrified of them. Whaling crews in particular detested sharks, as their operations attracted the largest predators alongside their ships, causing resentment at both the danger and the competition. Although some species such as the mackerel shark (makos, porbeagles, salmon sharks and great whites) are as tasty as swordfish or marlin, shark meat spoils quickly, making it commercially unviable on a large scale. Individual species have been over-fished – for their livers in particular. Some countries – Mexico, coastal India and Pakistan, the Phillipines, Taiwan – have long depended on sharks as an important part of their diets. In the Yucatan, the fillet of the young shark is considered a delicacy. In South East Asia, whole villages will share a whale shark, the fishermen docking the carcass as close as possible to the shore and the local population wading out to carve the flesh away. Such fishing is sustainable. Only the exploitation of sharks for shark-fin soup threatens shark populations worldwide.

In Europe and the English-speaking world, sharks have been widely seen as 'trash fish'. Eighteenth- and nineteenth-century sailors routinely reported that the waters were teeming with

116

'Skinning the sharks – a phase of Florida's fish industry, Key West', c. 1926.

sharks. In the South Seas, Australia, the Caribbean, the east coast of Central America and parts of Africa, whalers and fishermen considered sharks a low-level terror, undulating in the water as they fed, apparently snapping at anything. They were also a nuisance to anyone wishing to haul their trophy fish aboard in anything resembling one piece. This combination of fear and hostility towards the competition coalesced into a popular loathing. Many fishermen, both commercial and recreational, bore such a dislike for sharks that they wouldn't eat them. Sharks were thrown back, more often dead than alive. The fisheries taking the most sharks were mainly the large, catch-all operations that harvested everything, and even there sharks were sometimes discarded.[4]

Markets selling shark frequently labelled it as 'white fish' or 'mako'. Fish houses in the southern US simply call it 'fish'. In the UK shark, usually spiny dogfish, is often referred to as 'rock salmon'. The popular myth has been that sharks are bad-tasting, even poisonous. Because shark flesh contains relatively high levels of urea, used by sharks to regulate their buoyancy, the meat can spoil quickly or acquire an off-taste if not handled properly, as bacterial enzymes convert the urea to ammonia.[5]

'Shark caught on Pacific Coast', undated photograph.

Even today fisheries that market sharks for their meat are relatively uncommon. These include the Norwegian Porbeagle fishery, the European Spiny Dogfish fishery, the Australian Southern School and Gummy Shark fishery, and some reef shark fisheries in the Indian Ocean and Red Sea.[6]

While the numbers of sharks marketed for human consumption have risen only modestly, shark populations are falling precipitously. Numerous scientific studies published in the last decade have identified huge declines in shark populations.[7] The problems include not only the usual – habitat loss due to pollution from coastal development, damage to reefs and depletion of prey species – but also popular and official disregard for sharks. Only a handful of countries have any controls over their fisheries, and no meaningful international regulations exist for shark fisheries.[8] In the words of eminent marine biologists Leonard Compagno and Sarah Fowler, 'Shark eradication programmes have been better resourced than shark conservation

Eugene Higgins,
*Boiling Shark Oil
– Aran Island*,
c. 1935, etching.

Sale of shark at a
Paris fishmonger,
1943.

and management programmes.'[9] Typically, such programmes
are responding to powerful interest groups, the local tourist
industry or local fisheries. Between 1959 and 1976 the State of
Hawaii killed or paid private parties to kill 4,668 tiger sharks, at
the cost of $182 per shark; no measurable decrease in shark
attacks was detected.[10] During the 1950s the Canadian Fisheries
Department launched a basking shark annihilation programme.
These sharks were considered pests because they became entan-
gled in fishing nets and often tore them.[11] Meanwhile, modern
industry affords us ever more efficient systems for catching and
processing vast numbers of fish with the use of long lines, sonar
and factory ships, our technology far outstripping the capacity
of the resource (in this case, sharks) to reproduce itself. Shark
finning and, to a lesser extent, fisheries that process sharks for
fertilizer and pet food have had a significant negative effect.

Quotas for commercial fisheries are based on the reproduc-
tive rates of bony fishes – which produce millions of eggs –

rather than on the more severe restraints of shark reproduction. Many shark species take twelve to fifteen years to reach sexual maturity. Their gestation cycles are as long as 22 months. They may produce as few as two or three pups, and mortality rates are high for young sharks, as other sharks like to eat them. For all their bulk and ferocity, sharks are ecologically fragile. Since they're typically the apex predator in their local food chain, nature doesn't need hordes of them and has therefore created a system of birth control, making sharks vulnerable in spite of the apparent vastness of our oceans.

Until recently, the most utilized part of the shark was the oil from its huge liver, sometimes weighing hundreds of pounds. Shark liver oil was used to waterproof boats, for oil lamps and vitamin supplements. Early settlers in Australia lit their homes with it.[12] Shark oil has been used in the tempering of steel, the manufacture of early margarine and paint, and as a high-grade

Albert Flamen, 'Men Pouring Liquid into the Mouth of a Shark', c. 1620–26, ink drawing.

lubricant.[13] During World War II it was the source of 75 per cent of the vitamin A produced in the United States, as well as much of that in Britain. In 1942 one San Francisco fisherman caught $17,500 worth of shark oil in four days.[14] During the height of the World War II boom (1941–6), shark factories sprang up all along the West Coast of the US – in San Francisco Bay, Tomales Bay and Puget Sound; also in the Canadian Maritimes and in Scotland, where basking sharks were plentiful. (The basking shark has a particularly enormous liver, both as a proportion of body weight and because these sharks are huge.) There was a sizeable shark oil factory in Cojimar, Cuba, the setting for Hemingway's *The Old Man and the Sea*. Some Gulf Coast factories cut the meat into steaks and shipped it frozen to South America, where shark meat was not disdained. West Coast fisherman reportedly threw away all but the livers,[15] and yet San Franciscans claimed that a mysterious 'white fish' was plentiful at fish markets throughout the war. They found it tasty and believed it to be shark.[16]

Travelling fork and knife in sharkskin case. Probably German, c. 1730–40.

Six forks and six knives in sharkskin box. English, c. 1720–40.

One shark product with prestigious associations is shagreen. Derived from the Persian *saghari* and the Turkish *sagri*, shagreen is really just the *haut* word for sharkskin. In fact, *sagheri* and *sagri* refer not to sharks, which were of little concern in ancient Persia and Turkey, but to horses' hindquarters. This soft hide was worked into a decorative pebbling or pocking. Sharkskin came by the same handsome texture naturally, and it was also a far more durable material.[17] Because of its thickness and cross-weave, sharkskin makes a very strong leather, approximately 50 per cent stronger than cowhide. Carpet sharks, zebra sharks, tope sharks and darkie-charlies are believed to make the best shagreen.[18]

A circular dome top shagreen box with silver mounts, the interior lined in walnut and bearing the maker's plaque of John Paul Cooper, c. 1900.

By the eighteenth century, Holland had produced a guild of fine sharkskin workers, called *segrynwerkers*. In France, fine leather made from sharkskin was called *galuchat*, named after the craftsman Jean-Claude Galuchat. The term *galuchat* is still used today for many antique ornamental jewellery boxes and specialty cases for silverware, spectacles, instruments, inkwells, snuff and watches. The great artisan who revived the use of shagreen was John Paul Cooper, a former architect and adherent of the Arts and Crafts style, whose London studio produced sharkskin objects including vases, candlesticks, ornamental boxes and picture frames.[19] Shagreen was rightfully expensive, since smoothing out the denticles without weakening or hardening the hide was highly laborious, but after World War I a New Jersey company called Ocean Leather Corporation engaged an industrial chemist named Theodore H. Kohler to develop an industrial process. Jealously guarding their secret denticle-removal method, Ocean Leather dominated the worldwide market for more than 50 years, providing the material for 'luxury leather goods',[20] particularly handbags, belts, wallets, boots, shoes and even some clothing. Sharkskin was considered a practical choice for the highly scuffable toes of children's

Cane with shark-skin handle.

shoes: 'A small boy's destructive energy, tameless as it may be, is simply no match for the impregnable hide of the shark!'[21] Sharkskin leather is still used today for boots, including high-end cowboy boots. Purses and wallets made from sharkskin have always been popular.

Typically, shagreen is worked until the denticles are ground down or fall out, but for some products, such as oars and sword handles, the rough surface provided by the denticles needed to be retained. The ancient Greeks used it for polishing furniture, with denticles retained.[22] In the great age of sail, sharkskin was used as sandpaper for scraping the decks. Towards the end of the nineteenth century, sharkskin with denticles was used to hold pince-nez in place.[23] Anti-pickpocket wallets were also manufactured with the sharp denticles intact. Like thorns, they would catch on the fabric of the pocket, preventing easy removal,[24] but this feature proved inconvenient (as well as scratchy) for the owner of the wallet. Among other innovative uses is for the hilts

Products made from sharks: shark fin soup, shark skin boots, perfume, medicine, jewellery.

of Japanese swords which, if covered with sharkskin, remain graspable even when bloody.

Sharkskin has also been recognized for its hydrodynamic properties, its denticles enabling swimmers to move faster through the water. Speedo now has a line of swimsuits manufactured not with actual sharkskin but with a fabric woven with grooves to simulate the effects of denticles on water passing over its surface. In this design nature anticipated human endeavour by some 400 million years.

Ever since Aristotle, sharks have been used for healing potions, from relief of toothache and earache to recent alternative medicine.[25] Shark products can also be found in cosmetic creams, perfumes and medicinal items, most notably 'Preparation H', a widely known haemorrhoid treatment. According to a theory called tumour anti-angiogenesis, developed by Dr Judah Folkman at Harvard Medical School, cancerous tumours are nourished by blood flow; thus, such tumours

can be diminished, if not killed, by restricting the supply of blood vessels. The theory proposes that cartilage, which has practically no blood vessels, might produce a chemical that blocks this angiogenesis, and this blocker could be effective in reducing cancerous tumours. After nearly 40 years of research, the results are still inconclusive, but that fact hasn't stopped a $50-million-per-year industry from springing up or the slaughter of tens of thousands of sharks in order to produce cartilage pills.[26] The success of this industry was inspired at least in part by a book, *Sharks Don't Get Cancer*, published in 1992 by Dr I. William Lane, a fishery industry executive. Cancer patients whose tumours prove unresponsive to traditional medicine will – understandably – try anything. And capitalism, our individual enterprise system, has always been responsive to the desperation of those willing to pay. So what's the harm if seriously ill people keep up their hopes by taking shark cartilage pills, a remedy with no demonstrated effectiveness but also no harmful effects?

According to Dr Carl Luer, biomedical program manager at Mote Marine Laboratory, sharks and rays do indeed seem to have a lower incidence of cancer. When scientists exposed sharks to carcinogenic chemicals in their food and tank water, and injected known cancer-causing agents into their muscles, no tumours were detected.[27] Such heavy doses of carcinogens would surely have killed most rats, monkeys and other mammals. Mote researchers are also experimenting with the differences between sharks and mammals in their regulation of immune cells.[28] Primitive as sharks may be, their immune systems may be more effective in utilizing antibodies. Sharks also seem to be highly resistant to infection, leading scientists to the development of a drug containing shark cartilege called Squalamine (*squalus* is the Latin word for 'shark'), an organic chemical that in early tests has proven approximately as effective against bacteria as ampicillin.

Dr Luer cautions that 'human health applications from our research . . . will rely on continued funding and active collaboration with the drug industry and medical community.'[29] And the continued availability of sharks.

Other parts of the shark typically used are the fins, sold at premium prices to Chinese traders. For as long as 2,000 years, shark fins have been among the most valuable products from the sea,[30] being the essential ingredient in that traditional food of the emperors, shark-fin soup. During the more doctrinaire days of Maoism, China forbade the preparation of shark-fin soup, considering it a relic of bourgeois imperial rule, but that law was repealed in 1987. Now, under free-market socialism, shark fin is far more popular than ever before. The reported worldwide harvesting of sharks more than doubled between 1980 and 1990 and has continued to soar. China now uses almost 10,000 tonnes of shark fins a year, with Hong Kong importing roughly 52 per cent of that total.[31] But this figure measures only the *reported* numbers of sharks killed, not the hundreds of thousands, probably millions, of sharks poached

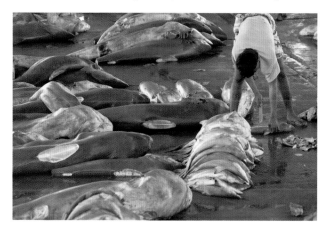

A man fins thousands of sharks, Yemen.

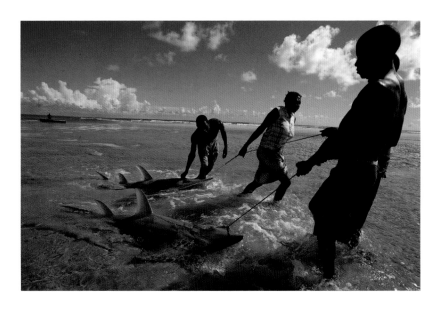

and finned on less legitimate fishing trawlers, or caught by the many informal shark-finners operating in the Philippines and along the Baja Coast of Mexico. Here fishermen drag the sharks on to the beach, load the fins into the back of pickup trucks and leave the carcasses on the sand. The problem can be reduced to capacities: fishermen who use the whole shark cannot kill so many sharks. They are limited by the capacities of their boats or trawlers, as well as the need to get the sharks to market quickly before they spoil. Shark fins, however, are easily sliced off and stored and weigh only a small fraction of the shark's total weight; thus a shark-*finning* ship might kill 50 times as many sharks as a shark-*fishing* trawler.

Shark-fin soup is considered prestigious, a sign of success, a dish to serve at weddings, banquets and other ceremonial occasions. A recent set of events involving not only the government of

128

the most populous nation in the world but also the Walt Disney Corporation suggests what strange and dangerous times we live in – strange for us, dangerous for the shark. Disney Hong Kong ran into unexpected trouble over what it considered to be a trivial offence: the serving of shark-fin soup at its theme-park restaurants. Initially, Disney employed the when-in-Rome defence, claiming that shark-fin soup is such a traditional feature of the Chinese banquet menu as to be iconic; in fact, Disney asserted, it would be insulting to Chinese culture not to serve the soup. That was before the letters from schoolchildren began pouring in.[32]

At around $65 to $150 per bowl, shark-fin soup does tend to impress the guests. 'Traditional', though, isn't entirely accurate since, outside emperors' palaces and Guangzhou, shark-fin soup was never widely served. In Guangzhou the dish has some history, but Disneyland Hong Kong is nowhere near Guangzhou.

Disney's next proposal was to offer shark-fin soup only upon request and then to present a pamphlet on the environmental issue whenever a customer ordered the soup. It turned out that Green Power, the environmental group charged with writing the pamphlet, had never heard of the plan and said it wouldn't go along with it if asked. So Disney presented a new idea: they would buy their shark fins only from 'responsible and reliable' sources that use the whole shark rather than those that 'fin' sharks and dump them overboard.[33] Unfortunately, though, once the fin has been detached from the shark, dealers' claims of 'responsible and reliable' behaviour can be verified only by DNA testing to match the fins and carcasses.

The postscript to the Disney shark tale is that, after a month of protests, climaxing with a deluge of emails to Disney's board of directors from environmental groups, marine scientists, scuba divers, stockholders and children, Disney Hong Kong

dropped shark-fin soup from the menu. The Disney Corporation denied that it was bowing to public pressure, however. Their press release read, 'After careful consideration and a thorough review process, we were not able to identify an environmentally sustainable fishing source, leaving us no alternative except to remove shark's fin soup from our wedding banquet menu.'[34]

While the problem of large-scale shark-finning is by no means solved, or even reduced, by the actions of one theme park sensitive to public opinion, this incident does suggest that people can have an effect – if not on the suppliers of shark fins, then perhaps on the restaurants that serve this soup.

Kim Jong-Il, the ruler of North Korea, lists shark-fin soup as the *top three* of his favourite foods. This isn't because of its great taste and healthy effects: shark fin is reported to be so subtle that it's virtually tasteless; furthermore, Thai government surveys have determined that 70 per cent of shark fins tested contain hazardous levels of mercury. The most likely reason is that shark fins are purported to be a sexual tonic[35] – despite the medical fact that mercury causes sterility, birth defects and a severe loss of brain cells.

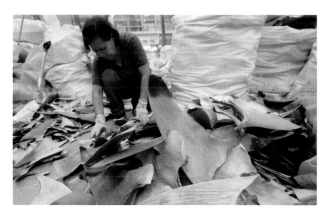

Shark fins, Mozambique.

The UN Food and Agriculture Organization estimates that 100 million sharks are caught and killed per year, many of them slaughtered for shark-fin soup. In Hong Kong alone, merchants handle thousands of tonnes of shark fins per year – numbers that represent tens of millions of sharks killed. The fins are sliced off while the sharks are still alive.

The problem is not merely that half a billion people have developed a taste for an expensive soup, or that advances in navigational electronics enable fishing fleets to roam the globe in search of not-yet-depleted fish stocks. Biological constraints are also part of the problem. Slow reproduction rates hold the populations of apex predators – sharks, lions, tigers, and bears – under some control. Unfortunately, nature's way of avoiding overcrowding at the top of the food pyramid has the unintended consequence of making shark species highly vulnerable to over-fishing. The real problem, of course, is the excess of another apex predator, *Homo sapiens*. It would seem that nature didn't plan for so many billions of us cleverly exploiting the other species, often wastefully, in order to enrich and amuse ourselves.

6 Useful in a Deeper Sense

That so many different shark species survive is testament not only to the brilliance of their basic design, but also to their role in the natural balance of the oceans. Yet shark populations are crashing wherever biologists have taken the time to measure them, and anecdotal evidence from divers and fishermen indicates a similar trend worldwide. Palaeontologists point out that sharks have survived four mass-extinction events during their 400 million years on earth and are therefore unlikely all to become extinct. Their tough lineage does not, however, guarantee the survival of individual species. Great white sharks are particularly pressured.

The case of the white shark suggests that a single determined man can make a difference, at least in a negative sense. Australian Vic Hislop sees it as his mission, as well as his business, to kill as many of these beasts as he can; he believes that every dangerous shark he kills makes the world safer for swimmers and sea lions.[1] Hislop has been diligent in pursuit of his goal for more than 25 years, running charters, catching large sharks for their jaws or for the freezer, and offering to hunt down sharks every time an attack occurs in Queensland or South Australia. A tireless self-promoter, Hislop operates a shark exhibition, called 'Shark on Show, The Best and Most Educational Shark Show in the World', in the coastal town of Hervey,

Queensland, Australia, with another branch at Airie Beach. Among his publicized theories are his contention that there exists a vast oversupply ('millions') of large dangerous sharks in Australian waters alone, that sharks that have attacked humans will continue to hunt us and that only a tiny percentage of the total shark attacks are reported; he also claims that he landed a female white shark measuring seven metres just south of Victoria in 1978.[2] Hislop maintains that it's a species war, us against them, with our position weakened by how many of 'us' are traitors, those who have taken up the cause of shark protection (singling out Peter Benchley, underwater photographers Ron and Valerie Taylor, and Rodney Fox). Although he protests against the recent laws protecting white sharks in Australian waters, Hislop claims that he never kills white sharks any more, only tiger sharks and other large species. The white shark carcass he recently sold to the artist Damien Hirst along with the tiger sharks had been frozen, Hislop insists, since well before the protection law went into effect in 1997.

The model for Benchley's sharkman, Captain Quint, was Frank Mundus, a legendary shark hunter famous for boozing and cussing on board and hoisting his monster catches on a forklift. In his bad old days, Mundus cut an adventurous figure, comprising equal parts romance and insolence. He would kill pilot whales for bait, lashing two or three to the back of his boat, then ride on the whale carcasses as the sharks drew near. Sailing out of Montauk, at the eastern tip of Long Island on the east coast of the United States, Mundus operated a shark-fishing charter operation with great success, killing many of the greatest of the great white sharks, the heavyweight monsters that follow whales north into the Atlantic Bight, along a thermocline of cold water edging the Gulf Stream. Not only did Mundus discover this pattern of white shark migrations, he also began the shark-

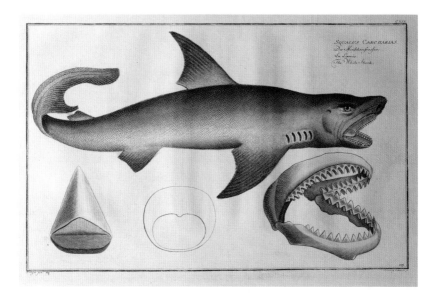

fishing tradition, trolling around in his slick of specially-smelly chum (spiked with meat from marine mammals), intuiting where to find the rarest, hugest specimens, then killing them and towing them into port to the widespread horror of local merchants and motel owners; meanwhile hooting with laughter, cussing and boozing, posing for photographs in his great white hunter hat beside his 'monsters'. Among his most famous exploits was driving one such monster through town balanced on the blades of a forklift. Perhaps the largest shark ever caught on rod and reel, a 1,545-kg female, was landed on Mundus' boat, but it was disqualified for any sport fishing record because he had used the wrong fishing line.[3]

Mundus himself killed an even larger shark with a harpoon in 1964. It was far too large to bring aboard his boat, so he towed it to the beach and dragged it ashore with a bulldozer. He

Andreas-Ludwig Kruger, *White Shark*, c. 1790, print.

then carved out the jaws, cut off the head and left the rest on the beach for scavengers, both human and animal. The mounted head was hanging in a harbourside saloon when Perry Gilbert, one of the most renowned shark experts of the day, arrived to inspect it. Perhaps less than scientifically, Dr Gilbert concluded, 'I've seen the jaw in the British Museum, and according to the record that shark was 35 feet [10.7 metres] long. That jaw is actually smaller than your seventeen and a half footer [5.3 metres]. I think that over the years the records were mixed up, and instead of 35 feet it should have been 3,500 pounds [1,588 kg]. Your fish must have weighed 4,500 pounds [2,041 kg] easily. Congratulations, Mr Mundus.' This made Mundus' day – and his career as a charter boat captain.[4] He boasts that he couldn't count the number of reporters who came to interview him.

Retired since 1996, Mundus now makes his home in Honaunau, on the Big Island of Hawaii, in the same area where traditional Hawaiians worshipped sharks as the reincarnation of their ancestors. It was in this part of the Islands where legends

Thomas Baines, *Man Measuring Two Dead Sharks on a Beach, Walvis Bay, Namibia*, 1861, watercolour on paper.

arose about *mano-kanaka*, shark men who could take human form and make mischief among island people, and where early Hawaiians offered human sacrifices to the sharks. Frank Mundus lives 370 metres up the side of a volcano; there he gardens and says that he no longer goes near the water.[5] Mundus has undoubtedly mellowed with age and success but, when asked whether his attitude towards sharks has changed now that he's retired and shark populations are plummeting, he replied, 'My attitude towards sharks has always been the same – towards any player in the game of games where the loser dies. I always did feel sorry for the loser. I like to win and will fight hard to win, but if I do win, I feel sorry for the one that lost.'[6] Of course, shark hunters don't die when they lose; they merely come back empty-handed.

Others admit to undergoing personal transformations in their attitudes towards sharks. South African shark-hunter-turned-preservationist Theo Ferreira was forever changed after witnessing a kind of anti-shark feeding frenzy. Following the grisly, fatal attack by a great white on a young woman who was scuba-diving at Mossel Bay in 1990, a *Jaws* scenario ensued, and 100 boats took to the water, killing every shark that could be hooked or harpooned. Like the Benchley character, Ferreira was hired to catch the perpetrator, the killer shark. Ferreira never found the culprit (nor, unlike its counterpart in *Jaws*, did it reappear to consume other members of the local population), but the hype and vigilante fever caused him to start asking questions about white shark research and conservation measures. These questions brought him into contact with Leonard Compagno, the world's leading shark systematist, and the Dolphin Action Protection Group. Along with his son, Craig, Theo Ferreira developed local funding for a new non-profit organization, while Dr Compagno recruited scientific research

groups. Meanwhile, the Dolphin Action Group ran a poll and found that 84 per cent of the population was in favour of some sort of white shark protection. All of this information was forwarded to the Minister of Environmental Affairs, and in April 1991 South Africa enacted the world's first white shark conservation laws. The Ferreiras founded the White Shark Research Institute in Cape Town, funding studies, monitoring adherence to protection measures and operating non-profit diving tours to the white shark feeding grounds off Dyer Island.[7]

Theo Ferreira recognized that no countervailing measures existed to control the periodic fits of public hysteria that followed a shark attack, or to balance the more constant pressure of those who see nature as our adversary. His was not an original discovery but, as a former shark fisherman, he made an effective advocate. What's more instructive is how his personal revelation indicates something greater than merely a change of attitude or political persuasion. Ferreira's conversion from shark hunter to shark protector implies an underlying shift from the traditional warrior virtues necessary to battle our enemies in nature – a role requiring the eyes of a hawk, dogged determination, nerves of steel, and so forth – to such skills as community organizing, coalition building, verbal persuasion and the willingness to subordinate the individual ego to an abstract greater good.

Theo Ferreira's story becomes more complicated after the founding of the White Shark Institute's eco-tourism operations, including cage diving at Gansbaai and Dyer Island. Cage diving is itself a complicated business, combining conservation ideology with moneymaking. Such operations are lucrative for non-profit and for-profit enterprises alike, since customers paying hundreds or thousands of dollars expect to see sharks. Operators are therefore strongly tempted to chum the water with a shark attractant comprised of smelly fish oil, blood and

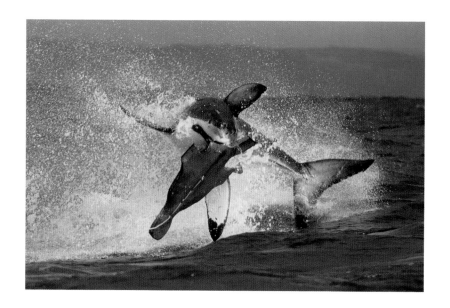

sometimes marine mammal parts. The largest white sharks prey on whales, seals and sea lions; they stake out pinniped rookeries.[8] Cage-diving operations approach as near as they're allowed to these rookeries or, if they're not allowed near the rookery, they try to lure the sharks with chum. Chumming alters the sharks' behaviour, though, exciting them and perhaps forming associations among the boats, cages and smell of humans in the water with the chum. In January 2006 Theo Ferreira was charged with acting irresponsibly after he had set up his cages and dispersed his chum less than two miles from a popular swimming and surfing beach in False Bay, South Africa. Ferreira maintained that the tide was going out, so no chum could drift towards shore; nevertheless, his licence was suspended.[9] It would seem only logical that sharks lured so close to the beach might find their own way for the last two miles.

Great white shark with a dummy seal. Many scientists object to the use of decoys to trick the wildlife and impress paying crowds.

A California eco-tourism entrepreneur ran into similar problems. Until October 1994 Jon Capella ran Tri-Sharks Charter Service, offering cage diving along the San Mateo coast and in the National Marine Sanctuary near Año Nuevo Island, which has a large elephant seal colony. To attract white sharks, Capella chummed with a mixture of fish entrails and blood and used silhouette cut-outs of sea lions. Capella claimed that his eco-tourism benefited sharks by showing them as majestic creatures in their native state; others pointed out that his operations lured white sharks away from the seal colony and to within a mile of swimming and surfing beaches and thus might invite the sharks to switch their natural prey.[10] Familiarity creates temptation. Capella was, of course, concerned with his business success, not with the well-being of surfers and swimmers, yet within his logic existed a valid point. Those who have seen a shark underwater, at least in clear visibility, often rhapsodize about the animal's beauty, power and poise. In fact, the problem that divers experience around sharks is not terror but the desire to follow them, approach them, even touch them. Such behaviour is very different to the anxiety experienced by some swimmers, who correctly conclude that the fish below can see them better than they can see the fish. This difference is not just our fear of the unseen and unknown – sharks can be better appreciated when seen in their entirety.

Aquaria like to display sharks, which are very popular attractions. The bigger the better. The argument made by their curators is that familiarity breeds understanding; people see the beauty of sharks, and they no longer loathe them. The Atlanta Aquarium, in Georgia, built with a donation of $250 million by Home Depot founder Bernie Marcus, set out to stock their giant tanks with whale sharks. Several died during their capture or transport before the aquarium managed to acquire four adoles-

cents, Ralph, Norton, Alice and Trixie. All were doing fine, and the crowds were pouring in, until Ralph died unexpectedly. He hadn't been eating, which the aquarium staff said was normal. As Marie Levine, director of the Shark Research Institute at Princeton University, has said, 'These sharks received the best medical care in the world.'[11] Yet one died for an unknown reason. It's true that viewing giant whale sharks educates thousands, if not millions, of people about the gentleness and value of these sharks. Seeing is believing. On the other hand, the wisdom of containing a pelagic species in any tank is questionable. Whale sharks migrate thousands of miles. They routinely dive down to over 1,200 metres, for reasons we don't understand. If an aquarium were to build a larger tank, would we display humpback whales? Presumably we would. Norton has since died too, and the Atlanta Aquarium is seeking replacements rather than reconsidering the wisdom of whale shark exhibitions.

The Monterey Bay Aquarium in California has had better luck displaying great white sharks. The aquarium has successfully released their second young shark star into the wild after 137 days in captivity and 600,000 viewers. The first, an adolescent female, was there for 198 days, from September 2004 until March 2005 (a cool million visitors) before she achieved release by starting to eat her tank-mates. The aquarium acquires its exhibits from California fishermen who find young sharks in their nets and would normally let them die rather than risk life and limb to free them. The aquarium staff study the sharks while displaying them, then, before releasing them at sea, tag them with a monitor that comes off after 90 days. This programme works advantageously for the aquarium and is arguably good for sharks, which need all the positive publicity they can get. As the Monterey Aquarium explains: 'White sharks are among the most maligned animals on Earth, and one

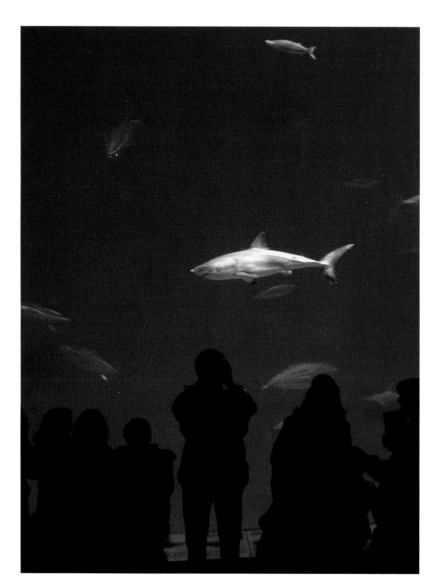

of many shark species worldwide threatened by human activities. We believe there's no better way for us to raise awareness about the threats white sharks face than to let people see for themselves what magnificent and fascinating animals they are, tell the story of the threats they face in the wild, and offer ways to take action that will protect white sharks.'[12]

Rodney Fox followed a similar path to that of Theo Ferreira, although it began rather more dramatically. Probably the most famous victim of shark attack, Fox was competing in a spear-fishing tournament in 1963 off Aldinga Beach near Adelaide, Australia, when he was struck by what he soon concluded was a large shark. He felt immense pressure squeezing his chest. He groped for the shark's eye, raking his hand across its teeth. After propelling Fox underwater for some distance, the shark released him. Fox rose to the surface, bleeding badly and desperate for air. As reported for the Shark Attack Files (case #1235), he watched the shark coming at him again:

> The water was very red with blood, and my face mask was half off. The next few moments were the most terrifying for me as I thought that – if he has another go at me, I'm finished. I pushed at him with my foot, and I felt my flipper touch him. Next thing, the fish buoy which I had been towing on 30 feet [9 metres] of cord disappeared, and I was dragged underwater again. I was trying to find the quick release catch on my belt when the cord broke, and I came to the surface.[13]

Although terribly wounded, Fox also enjoyed incredible luck. A nearby patrol boat had spotted the attack and rescued him immediately; he was rushed to hospital where the surgeon on duty was waiting, having just completed a special course in

Great white sharks are the centre of attention at the Monterey Bay Aquarium.

London on chest surgery. Fox's wetsuit also helped save him, holding his torn abdomen and lungs in place. He required 458 stitches.[14] Fox became the poster boy for shark attack, the photograph of his wounds creating terror in the imaginations of all who saw it.

More astonishing even than Rodney Fox's survival is that he was soon back in the water spear fishing. In fact, he was one of the winners of the same spear-fishing tournament the following year. Fox went on to dive for abalone in the same dangerous waters for eighteen years, during which time he was 'buzzed' by great whites on three occasions. During the same years, he frequently fished for great whites, catching and killing them as a kind of catharsis to his fear, or possibly a vendetta against the species that had mangled and so nearly killed him. With legendary shark hunter Alf Dean, Rodney Fox landed many monsters, sometimes several in a single day, but then his thinking began to change. After helping in the filming for *Jaws* – the actual shark footage was filmed off Dangerous Reef in South Australia, using a very small stuntman to make the surrounding sharks loom larger – Fox began to notice how scarce the great whites were becoming, even in waters where they'd once been more plentiful than anywhere else in the world. Fox now regrets his involvement with *Jaws*, not so much for the inaccurate and sensational depiction of a 'rogue shark' as for the movie's worldwide effect, inspiring thousands of fishermen to test their manhood against the great man-eaters.

Some people like to kill sharks. In 1946, when the oyster fishery off Moss Landing, near Monterey on the Central Coast of California, was collapsing, the oystermen decided if they could rid the area of oyster-eating sharks and rays, the oyster population would rebound. With shotguns, pitchforks and dynamite, the local citizenry killed hundreds of sharks and rays.

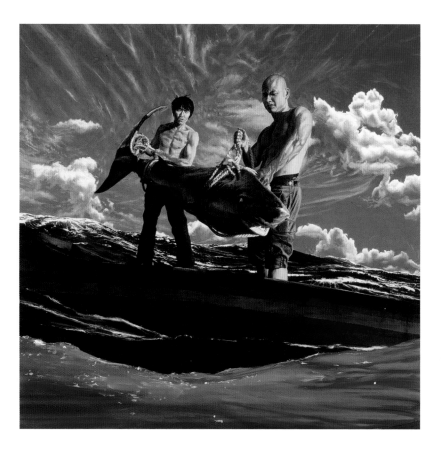

The oyster fishery collapsed anyway – and yet the annual shark and ray hunt continued.[15] On the Gold Coast of Australia in 2007, a man has pledged himself to the cause of ridding the canals and beaches of bull sharks. 'They're bastards. I'm going to eradicate them, I'm going to clean them out,' Ian Robinson has declared. 'I've got to get the sharks out of the water.' Besides worrying about 'kids jumping in the water and paddling

Steve Mumford, *South China Sea: Fishermen Throwing a Finned Thresher Shark Back into the Sea Amidst Heavy Swells and a Stiff Breeze*, 2002, oil on canvas.

around', Robinson believes that sharks make his favourite pastime, mud-crabbing, too dangerous. 'I can't go out in my kayak because it's not safe. I had one splash behind me when I was picking up the crabs – after that I stopped putting my feet in the water.'[16]

In addition to those with an active antipathy to sharks is at far more harmful group – those with a callous disregard. The restaurants that serve shark-fin soup are far removed from Cocos Island or Baja or Western Australia, where many millions of sharks are finned. Hong Kong businessmen deal in dollars and kilograms (or tonnes), not in sharks themselves. We humans have an extraordinary capacity for abstraction and compartmentalization – also misperception. The oceans are perceived as vast and plentiful, and filled with dangerous creatures. It is not widely known that bees and dogs kill far more of us than sharks do. Very few shark attacks go unreported, even when they occur on the remotest islands. The media thrills to the details of every shark encounter; their fright value is reliable. Few people realize that only four shark species are truly dangerous, and that even these (white sharks, bull sharks, tiger sharks and oceanic whitetips), so often featured on cable television, usually take no interest in us. We hear about the aberrations, typically shark mistakes, when one of them confuses one of us with a sea lion, when a shark feeding on fish in turbid water accidentally nips a human foot. If sharks were to go after us in the way we go after them, no *Homo sapiens* would swim in the sea.

The killing of sharks has often been seen as a public service, like rounding up rattlesnakes or eradicating the nests of poisonous spiders. In the eastern Gulf of Mexico alone, the number of shark-fishing tournaments has grown from six in 1973 to more than 70 today.[17] According to George Burgess, Director of the

International Shark Attack File at the Florida Museum of Natural History, 'We can really date the beginning of the decline of the US Atlantic shark population to the release of the movie *Jaws* in 1975. The movie got recreational anglers interested in catching sharks, which led to the creation of numerous shark-fishing tournaments. Soon the shark population began to decline. This decline picked up pace in the early 1980s when commercial anglers got involved in a big way.'[18] These commercial fishermen invested in boats and equipment without ever evaluating whether shark populations could support large-scale fishing operations. As occurred with swordfish and cod, fishing operations with heavy debt pursued fewer and fewer fish as the stocks diminished. Another problem is the irrelevance of national laws and quotas applied to fish that swim freely across international borders. Restrictions passed on Canadian fishermen harvesting porbeagles in the North Atlantic just leave more fish for US fisheries. Trawlers from many faraway countries caused the numbers of basking sharks in British waters to plummet. Furthermore, when no verifiable data exists for ocean populations, highly interested parties are likely to disagree about whether a problem even exists. It is easy for legislators to keep their heads in the sand since no one can count the fish in the sea.

It is also easy to despair about our chances of controlling the many shark hunters and fisheries that operate at the fringe of legitimacy. World Heritage Sites and Marine Reserves, like the Galapagos and Cocos Island, are increasingly raided by shark-fin trawlers as shark populations outside protected areas decline.[19] What makes the situation seem even more hopeless is the nature of many of those shark-fin suppliers. According to investigations by a group called Wild Aid, the people who were trafficking in illegal ivory switched to shark fins after the ivory trade was banned in 1989.[20] But the fact is, poachers and illegal traders have

Finning baby sharks for market, Trinidad, West Indies.

Chinese School, 'Sword Snouted Shark, *Eeu parrang, Squalus poristis*', from 'Drawings of Fishes from Malacca', c. 1805–18, watercolour on paper.

always been with us. The solution to slavery was not to control the slave traders but to abolish slavery. Similarly, the only way to eliminate the practice of shark finning – slicing off the fins and discarding the shark – is to reduce the demand. Obviously, the governments of some nations, particularly the Chinese government, will be less susceptible to public pressure and the letter-writing campaigns of school children than others, but no nation wishes to be seen as a pariah state. Our economies are too inter-dependent.

Under pressure from international environmental groups, the Ecuadorian government outlawed shark fishing at the Galapagos Islands and the exportation of shark fins. However, these laws were never actively enforced, and in 2005 President Guiterrez decreed that sharks could be killed and finned as long as they were 'by-catch'.[21] Observers estimate that in 2006 *aleteros* (shark finners) killed 600,000 sharks in and around the Galapagos Marine Sanctuary.[22] These fins are openly traded in the Ecuadorian port of Manta.

China's leading e-commerce company, Alibaba.com, specializes in import and export, including shark fins. At the time of writing, they list on their website 125 shark-fin suppliers from

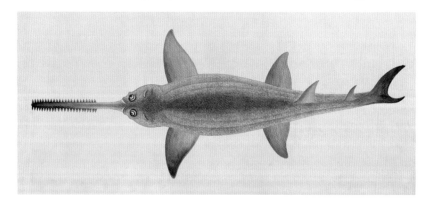

30 countries: Mexico, Uruguay, Costa Rica, El Salvador, Peru, Chile, Brazil, Mauritania, Kenya, Somalia, Yemen, United Arab Emirates, Egypt, Madagascar, Sri Lanka, Bangladesh, India, Maldives, Malaysia, Indonesia, Singapore, Vietnam, Taiwan, Mainland China, South Korea, Canada, United States, Spain and United Kingdom. Alibaba is 40 per cent owned by Yahoo.com, which reportedly paid a billion dollars for its stake in this Internet marketplace. It will not be easy to control shark-fin trafficking.

Unless we can reverse current trends, the next 20 years will certainly see the extinction of many shark species, with many more to follow, and the solutions involve more than a UN resolution or a letter-writing campaign directed at Disney, Yahoo or the Politburo of the Chinese Communist Party. The preconditions of both our active antipathy and our passive disregard require a change in our basic attitudes, both a sober and an imaginative consideration of what will be lost when the sharks disappear, with many becoming extinct without our even noticing. There are more creatures in the oceans than we know about but, other than whales and dolphins with their mammalian eyes, none fascinates or arouses us more than the shark. Ever since the Age of Dinosaurs, sharks have reigned as top

Chinese School, 'Shark, Eekan Ee-oo', from *Drawings of Fishes from Malacca*, c. 1805–18, water-colour.

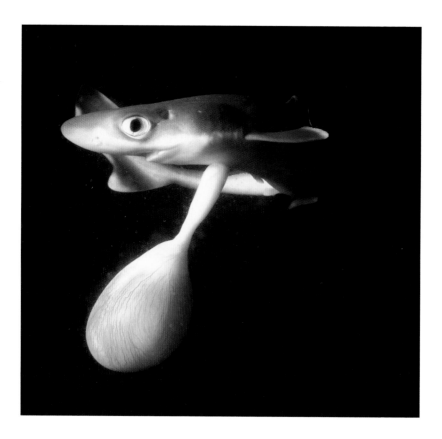

Newborn Spiny Dogfish (*Squalus acanthias*) with yolk sac still attached, New England, North Atlantic Ocean.

predators in their realm. They're also one of Mother Nature's greatest art forms, where she expresses herself most ingeniously and extravagantly. Shark populations are threatened not because of any design flaw, but because of our own species' disregard and callous misrepresentations of them. What's surprising is that we, for all our brain cells, show so little understanding of sharks' natures and their place in the ocean's biological systems. In Europe and the English-speaking parts of the world, sharks

have been vilified as omens of evil, harbingers of bad luck, monsters and satanic creatures that rise from the deep. In those places where sharks were more common, people tended to deify rather than demonize them, domesticating the danger, but still not comprehending the shark.

Our willingness to avoid the eradication of shark species is therefore a kind of test, not only of our ability to accept responsibility as stewards of the planet but also of our capacity to transcend the bounds of our self-regard.

Timeline of the Shark

c. 400 MYA (DEVONIAN PERIOD)

(*Cladoselache*, a primitive shark with three-pointed teeth, appears

c. 320 MYA (CARBONIFEROUS PERIOD)

Shark-like *Stethacanthus* and *Helicoprion* seem to be direct ancestors of modern sharks, but the evolutionary winner is *Hybodus*, a 2.4-metre shark with two sets of differently functioning teeth

c. 200 MYA (JURASSIC PERIOD)

By the Miocene Epoch (*c.* 25 MYA), all current shark families exist. The huge *Carcharodon megalodon*, growing to eighteen metres or more, rules the seas

1667

Danish anatomist Nicholas Steno (aka Niels Stensen) describes his dissection of the head of a giant white shark and correctly identifies fossilized shark teeth, previously thought to be serpent tongues

1851

Moby-Dick is published

1891

Archaeologist Charles H. Sternberg finds in Kansas the complete fossil, including 250 teeth, of *Cretoxyrhina mantelli*, a six-metre shark similar to the great white shark

1916

In July five young men and boys along the New Jersey coast suffer shark attacks, four of them fatal. These attacks give birth to the 'rogue shark' myth that becomes the model for *Jaws*

1970

Publication of Jacques Cousteau's *The Shark: Splendid Savage of the Sea*

1971

Release of Peter Gimbel's fascinating documentary about sharks, *Blue Water White Death*

1975

Release of *Jaws*, the Steven Spielberg movie that launched a thousand shark-fishing boats and kept millions of bathers out of the water

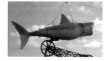

1977

Arthur 'Fonzie' Fonzarelli jumps a shark on the American television comedy *Happy Days*, giving birth to an expression for highly desperate dramatic measures by a TV show: 'jumping the shark'

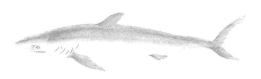

c. 10,000–15,000 YEARS AGO	492 BC	1569
Recent evidence from megalodon teeth indicates that these sea monsters are still extant well into the era of human seafaring	Herodotus describes hordes of 'monsters' devouring the ship-wrecked sailors of the Persian fleet: the first written record of a shark attack	First use of word 'shark' in English. Previously, English sailors and fishermen used the term 'sea dog' or the Spanish *tiburon*

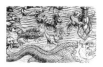

1930	1945	1959	1969
A Canadian scientific publication reports the discovery of a great white shark measuring 11.3 metres in length	Sinking of the USS *Indianapolis*	The first summer with numerous shark attacks reported on the West Coast of the United States	Free-diver Ramon Bravo finds a cave full of snoozing sharks near Isla Mujeres, off the Yucatan Peninsula of Mexico

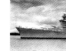

1987	2000	2005	2006
The Chinese government rescinds its ban on shark-fin soup	'The Summer of the Shark', as dubbed by *Time* magazine. According to the International Shark Attack File, the number of attacks was only slightly elevated from normal	The year in which sharks killed per annum reached 100 million: approximately 3.5 million of them killed by us for each one of us killed by them	Peter Benchley, author of the novel *Jaws*, dies. Benchley had become an active shark conservationist

References

INTRODUCTION

1 Peter Gimbel, 'Shark!' *Sports Illustrated* (29 August 1966).
2 http://www.livescience.com/imageoftheday/siod_050425.html
3 David Quammen, *Monster of God* (New York, 2003), pp. 13–14.
4 http://news.nationalgeographic.com/news/2006/09/060918-walking-shark.html
5 Elizabeth Kolbert, 'The Darkening Sea', *The New Yorker* (20 November 2006).

1 A TIMELESS DESIGN

1 http://news.nationalgeographic.com/news/2003/10/1001_031001_sharkfossil.html
2 Jeff Klinkenberg, 'The big, bad bully of the sea', *St Petersburg Times*, (25 June 2006).
3 Richard Ellis and John E. McCosker, *Great White Shark* (Stanford, CA, 1991), p. 47.
4 http://www.elasmo-research.org/education/white_shark/smell.htm
5 Ellis and McCosker, *Great White Shark*, p. 72.
6 R.W. Murray, 'The Response of the Ampullae of Lorenzini of Elasmobranchs to Mechanical Stimulation', *Nature* (1960).
7 Thomas H. Lineaweaver III and Richard H. Backus, *The Natural History of Sharks* (New York, 1970), p. 203.
8 Andre M. Boustany, Scott F. Davis, Peter Pyle, Scot D. Anderson, Burney J. Le Boeuf and Barbara A. Block, 'Satellite tagging: Expanded niche for white sharks', *Nature*, 415:35–6 (3 Jan 2002).

9 Quoted in Lineaweaver and Backus, *Natural History of Sharks*, p. 181.
10 Demian Chapman et al., 'Virgin Birth in a Hammerhead Shark', *Biology Letters* (May 2007).
11 http://www.nytimes.com/2007/05/23/science/ 23shark.html?ex=1181102400&en=4375acaaad84f0f0&ei=5070
12 ReefQuest Centre, http://www.elasmoresearch.org/education/ topics/b_40_winks.htm
13 Charles Sprawson, 'Profile: Swimming With Sharks', *New Yorker* (23 August 1999).
14 Leonard Compagno, Marc Dando and Sarah Fowler, *Sharks of the World* (Princeton and Oxford, 2005).
15 Richard Ellis, *The Book of Sharks* (New York, 1975).
16 Compagno et al., *Sharks of the World*, p. 126.
17 Ellis and McCosker, *Great White Shark*, pp. 44–5.

2 DEITIES AND DEMONS

1 http://www.clas.ufl.edu/jur/200209/papers/paper_morey.html
2 Leighton Taylor, *Sharks of Hawai'i: Their Biology and Cultural Significance* (Honolulu, 1993), p. 26.
3 Ibid., p. 27.
4 Ibid.
5 http://www.volunteerincookislands.org/coinfo.htm
6 Harold W. McCormick and Tom Allen, *Shadows in the Sea* (New York, 1963), pp. 145–6.
7 Ibid., p. 144.
8 Dennis O'Rourke, *The Shark Callers of Kontu*, documentary film, Direct Cinema (Los Angeles, 1987).
9 Linnaeus, among others, speculated that Jonah might have been swallowed not by a whale, but by a white shark, which would have made more anatomical sense. If so, this encounter might have been the only instance in which the shark escaped the blame.
10 Although popular shark hysteria flared up on the East Coast of the US following the Matawan attacks of 1916, it subsided after World War I.

11 Quoted in Richard Ellis and John E. McCosker, *Great White Shark* (Stanford, CA, 1991), p. 174.

12 http://www.imdb.com/title/tt0073195/quotes

13 Doug Stanton, *In Harm's Way* (New York, 2001), p. 249.

14 See http://www.ussindianapolis.org/woody.htm

15 Stanton, *In Harm's* Way, p. 249.

16 http://www.ussindianapolis.org/woody.htm

17 Richard G. Fernicola, *Twelve Days of Terror* (Guilford, CT, 2001), pp. 8–9.

18 Ibid., p. 19.

19 Ibid., p. 13.

3 OUR SENSATIONAL IMAGINATIONS

1 Herman Melville, *Moby-Dick* [1851] (Berkeley, CA, London, 1979), p. 309.

2 Ibid., p. 191.

3 http://www.signonsandiego.com/news/nation/20060212-1810-obit-benchley.html

4 Ernest Hemingway, *Islands in the Stream* (New York, 1970), pp. 85–6.

5 Ernest Hemingway, *The Old Man and the Sea* (New York, 1952), pp. 100–101.

6 Robert Stone, *A Flag for Sunrise* (New York, 1981), p. 226.

7 Ibid.

8 Ibid., p. 230.

9 Ibid., p. 231.

10 Tom Engelhardt, 'Shark and Awe: Weaponizing the Shark and Other Pentagon Dreams' at http://www.tomdispatch.com

11 http://www.truthout.org/cgi-bin/artman/exec/view.cgi/48/18222

12 http://www.defensetech.org/archives/001655.html

13 Carol Vogel, 'Swimming With Famous Dead Sharks', *New York Times* (1 October 2006).

14 Ibid.

15 Gordon Burn and Damien Hirst, *On the Way to Work* (London, 2001), p. 13.

16 http://www.felixsalmon.com/000344.html

17 http://arts.guardian.co.uk/saatchi/story/0,,928850,00.html

18 See http://www.damienhirst.com

19 Annabel Crabb, http://www.theage.com.au/news/national/the-shark-hunter-the-artist-and-a-nice-little-earner/2006/07/01/1151174441325.html

20 Ibid.

21 According to George B. Allen's research (*The Shark Almanac*, p. 217), the weapon is a harpoon, not a boat hook, and the harpooner's pose resembles an altar, painted by Rafael, that depicts the Archangel Michael using a spear to drive Satan out of heaven.

22 http://www.nga.gov/feature/watson/story1.shtm

23 Ibid.

24 http://www.strangescience.net/stsea2.htm

25 Konrad Gesner, *Historiae Animalium* (1551–8), trans. from the German *Thierbuch* (Zurich, 1563).

4 UNSCRUPULOUS LAWYERS AND OTHER PREDATORS

1 Thomas B. Allen, *The Shark Almanac* (New York, 1999), p. 3.

2 *Oxford English Dictionary*, Compact Edition, vol. II (Oxford, 1971), p. 2771.

3 http://www.economicexpert.com/a/moneylending.html

4 http://www.ezinearticles.com/?stress-management:-sharks-and-dolphins-at-work&id=68767

5 http://snltranscripts.jt.org/75/75djaws2.phtml; http://en.wikipedia.org/wiki/landshark.

6 http://www.sinteticor.com/artist 1/louis armstrong lyrics/mack the knife lyrics.htl

7 Cited in David Morris, 'Gothic Sublimity', *New Literary History* (Winter 1985) summarizing *The Standard Edition of the Complete Psychological Works of Sigmund Freud*, vol. XVII, trans. James Strachey (London, 1955), p. 240.

1 These estimates are actually conservative since many of the largest shark-finning operations are illegal and therefore unmonitored. These numbers are cited in many sources, including: http://blog.sciencenews.org/food/2006/11/souped_up_new_ estimates_of_the.html and http://news.bbc.co.uk/2/hi/science/ nature/817766.stm

2 *Nature*, January 2005.

3 http://www.iucn.org/en/news/archive/2006/05/02_pr_red_ list_en.htm

4 Leonard Compagno, Marc Dondo and Sarah Fowler, *Sharks of the World* (Princeton and Oxford, 2005), p. 45.

5 Ibid., p. 46.

6 Ibid., p. 45.

7 Ibid., p. 49.

8 http://www.ecoworld.com/home/articles2.cfm?tid=246

9 Compagno et al., *Sharks of the World*, p. 49.

10 http://www2.hawaii.edu/~carlm/tigershark.html

11 http://www.pelagic.org/montereybay/pelagic/baskingshark.html

12 Harold W. McCormick and Tom Allen, *Shadows in the Sea* (New York, 1963), p. 193.

13 Ibid., p. 194.

14 The information in this and the previous sentence comes from Thomas B. Allen, *The Shark Almanac* (New York, 1999), p. 231.

15 Ibid.

16 I heard this often from family and friends when I was growing up in and around San Francisco.

17 Allen, *Shark Almanac*, p. 236.

18 Steve and Jane Parker, *The Encyclopedia of Sharks* (New York, 2002), p. 165.

19 N. Natasha Kuzmanovic, 'The Shagreen Work of John Paul Cooper', *The Antiques Magazine*, September 1995.

20 McCormick and Allen, *Shadows in the Sea*, pp. 196–7.

21 Ibid., p. 198.

22 Ibid., p. 194.
23 Ibid.
24 Ibid., p. 238.
25 Ibid., p. 230.
26 Ibid., p. 232.
27 Ibid., pp. 232–3.
28 Ibid., p. 233.
29 Ibid.
30 Compagno et al., *Sharks of the World*, p. 46.
31 See http://www.underwatertimes.com/news.php?article_id=
 51018346029. This statistic is reported as of 10 November 2006.
32 Walt Disney News:
 http://www.mickeynews.com/news/displaypressrelease.asp_q_i
 d_e_6255fin
33 Ibid.
34 Ibid.
35 McCormick and Allen, *Shadows in the Sea*, p. 191. According to
 McCormick and Allen, Pliny provided Romans with the recipe to
 counteract the aphrodisiac effects of shark-fin soup: the liver of
 the torpedo ray.

6 USEFUL IN A DEEPER SENSE

1 Richard Ellis and John E. McCosker, *Great White Shark* (Stanford,
 1991), p. 239.
2 http://www.ozmagic3.homestead.com/vichislopmythsfacts.html
3 Ellis and McCosker, *Great White Shark*, p.195.
4 Robert F. Boggs, *Shark Man* (Lorenz Press, 1977), pp. 131–2.
5 Interview with the author (September 2003).
6 Correspondence with the author (December 2006).
7 http://www.whiteshark.co.za
8 Pinnipeds are sea otters, sea lions, walruses and seals, including
 the huge, blubbery elephant seals that white sharks prefer.
 Pinniped is Latin for 'feather foot', describing the animals' caudal
 fins.

9 http://www.cdnn.info/eco/e040129b/e040129b.html

10 http://www.montereybay.noaa.gov/intro/advisory/
rapma/941021.html

11 'Death of a Shark Leaves Scientists Grasping', Shaila Dewan,
New York Times, 13 January 2007.

12 http://www.montereybayaquarium.org/whiteshark

13 http://www.flmnh.ufl.edu/fish/sharks/isaf/isaf.htm

14 Ellis and McCosker, *Great White Shark*, pp. 149–50.

15 http://www.earthwatch.org/site/pp.asp?c+dsjsk6pfjnh
&c=2296251

16 http://www.underwatertimes.com/news.php?article_id
=50126410739

17 http://www.hsus.org/wildlife/issues_facing_wildlife/shark_
tournaments/sharks_in_the_us_white_paper.html

18 http://www.flseagrant.org/library/publications/fathom_
magazine/volume-8_issue-2/predators.htm

19 http://www.ecoworld.com/home/articles2.cfm?tid=246

20 Ibid.

21 http://www.oceanicdreams.com/article_slaughter.html

22 Ibid.

Bibliography

Aldrovandi, Ulyssis, *Monstrorum historia cum Paralipomensis omnium animalium*, Bononaie: Typis Nicolai Tebaldini (1642)

Allen, Thomas B., *The Shark Almanac* (New York, 1999)

Belleville, Bill, *Sunken Cities, Sacred Cenotes, & Golden Sharks: Travels of a Water-Bound Adventurer* (Athens and London, 2004)

Benchley, Peter, *Jaws* (New York, 1974)

—, *Shark Trouble* (New York, 2002)

—, *White Shark* (New York, 1994)

Boggs, Robert F., *Shark Man* (Dayton, OH, 1977)

Bright, Michael, *Sharks* (Washington and London, 2002)

Budker, Paul, *The Life of Sharks* (London, 1971)

Burn, Gordon and Damien Hirst, *On the Way to Work* (London, 2001)

Carrier, Jeffrey C., John A. Musick and Michael R. Heithaus, eds, *Biology of Sharks and Their Relatives*, (New York, London, Washington DC, 2004)

Carwardine, Mark and Ken Watterson, *The Shark Watcher's Handbook* (Princeton and Oxford, 2002)

Casey, Susan, *The Devil's Teeth* (New York, 2005)

Castro, Jose I., *The Sharks of North American Waters* (Texas, 1983)

Clark, Eugenie, *The Lady and the Sharks* (New York and London, 1969)

Collier, Ralph S., *Shark Attacks of the Twentieth Century From the Pacific Coast of North America* (Chatsworth, CA, 2003)

Compagno, Leonard, Marc Dando and Sarah Fowler, *Sharks of the World* (Princeton and Oxford, 2005)

Cousteau, Jacques-Yves, *The Shark: Splendid Savage of the Sea* (New York, 1970)

Cousteau, Jean-Michel and Mose Richards, *Cousteau's Great White Shark* (New York, 1992)

Drumm, Russell, *In the Slick of the Cricket, A Shark Odyssey* (New York, 1997)

Ebert, David A., *Sharks, Rays and Chimaeras of California* (Berkeley, Los Angeles, London, 2003)

Edwards, Hugh, *Sharks and Shipwrecks* (New York, 1975)

Ellis, Richard, *Encyclopedia of the Sea* (New York, 2001)

—, *The Book of Sharks* (New York, 1975)

Ellis, Richard and John E. McCosker, *Great White Shark* (Stanford, CA, 1991)

Fernicola, Richard G., *Twelve Days of Terror* (Guilford, CT, 2001)

Gesner, Konrad, *Historia Animalium* (1551–8), trans. from the German *Thierbuch* (Zurich, 1563)

Hamlett, William C., ed., *Sharks, Skates, and Rays: The Biology of Elasmobranch Fishes* (Baltimore and London, 1999)

Hemingway, Ernest, *Islands in the Stream* (New York, 1970)

—, *The Old Man and the Sea* (New York, 1952)

Klimley, A. Peter, *The Secret Life of Sharks* (New York, 2003)

Klimley, A. Peter and David G. Ainley, eds, *Great White Sharks, the Biology of Carcharodon carcharias* (San Diego, London, Boston, New York, Sydney, Tokyo and Toronto, 1996)

Lane, I. William and Linda Comac, *Sharks Don't Get Cancer* (New York, 1992)

Lawrence, R. D., *Shark! Nature's Masterpiece* (Shelburne, VT, 1985)

Lineaweaver, Thomas H. III and Richard H. Backus, *The Natural History of Sharks* (New York, 1970)

McCormick, Harold W. and Tom Allen, *Shadows in the Sea* (New York, 1963)

Marriott, Edward, *Savage Shore: Life and Death with Nicaragua's Last Shark Hunters* (New York, 2000)

Matthiessen, Peter, *Blue Meridian: The Search for the Great White Shark* (New York, 1971)

May, Nathaniel, ed., *Shark, Stories of Life and Death from the World's Most Dangerous Waters* (New York, 2002)

Melville, Herman, *Moby-Dick* [1851] (Berkeley, Los Angeles, London, 1979)

Musick, John A. and Beverly McMillan, *The Shark Chronicles* (New York, 2002)

O'Rourke, Dennis, *The Shark Callers of Kontu*, documentary film, Direct Cinema (Los Angeles, 1987)

Oxford English Dictionary, Compact Edition, vol. II (Oxford, 1971)

Parker, Steve and Jane, *The Encyclopedia of Sharks* (New York, 2002)

Quammen, David, *Monster of God* (New York, 2003)

Rothfels, Nigel, ed., *Representing Animals* (Bloomington, IN and Indianapolis, 2002)

Rothman, Jeffrey L., *Shark!* (New York, 1999)

Schwartz, Frank J., *Sharks, Skates, and Rays of the Carolinas* (Chapel Hill, NC and London, 2003)

Stafford-Deitsch, Jeremy, *Shark: A Photographer's Story* (San Francisco, 1987)

Stallabrass, Julian, *High Art Lite: British Art in the 1990s*, (London, 1999)

Stanton, Doug, *In Harm's Way* (New York, 2001)

Stone, Robert, *A Flag for Sunrise* (New York, 1981)

Taylor, Leighton R., *Sharks of Hawai'i: Their Biology and Cultural Significance* (Honolulu, 1993)

White, Peter, *The Farollon Islands* (San Francisco, 1995)

Associations and Websites

Reef Quest Centre for Shark Research operates this superb website 'to provide resources for educators and students, facilitate collaborations between researchers, and foster public awareness of the beauty, diversity, and vulnerability of sharks and rays', with excellent text and illustrations by R. Aidan Martin and Anne Martin:
http://www.elasmo-research.org/index.html

White Shark Research Program operates on a shoestring budget under the auspices of the Point Reyes Bird Observatory, Point Reyes National Seashore, California, but their research discoveries about white shark behaviour are among the most exciting in the world:
http://www.prbo.org/cms/index.php?mid=68/shark.htm

Florida Museum of Natural History provides reliable online ichthyology and houses the International Shark Attack Files, for which one must apply for access:
http://www.flmnh.ufl.edu/fish/sharks

The Massachusetts Division of Marine Resources set up a website to chronicle visually the adventures of a great white shark that in 2004 became trapped in a Cape Cod salt pond and was ultimately helped to free itself by a team of committed, eager volunteers:
http://www.mass.gov/dfwele/dmf/marinefisheriesnotices/white_shark.htm

Shark Research Institute at Princeton University has brought together some of the most distinguished shark scientists in the world, including South Africans Marie Levine and Leonard Compagno. SRI also compiles the Global Shark Attack File. This website provides news reports, conservation information and opportunities to contribute money to their research:
http://www.sharks.org

The Mediterranean Shark Research Group provides information about sharks and a long list of links, including many to Italian researchers and organizations not well publicized elsewhere:
http://www.elasmoworld.org/mediterraneangroup/links.shtml

The White Shark Research Institute in Capetown, South Africa, promotes shark conservation and research, as well as its own cage-diving excursions:
http://www.whiteshark.co.za

The Collaborative White Shark Research Programme, in South Africa, provides news and some research grants for shark-tagging projects. They also welcome volunteers wishing to work on these projects at Dyer Island and Gansbaai:
http://www.sharkresearch.org/pages/index.html

The Bimini Biological Field Station Sharklab, owned and operated by biologist Dr Samuel H. Gruber of Miami University, offers internships in shark research and conservation:
http://www6.miami.edu/sharklab/index.html

The Apex Predators Investigation, sponsored by the Narragansett Laboratory of the National Marine Fisheries Service, is conducting an extensive shark-tagging programme in the Atlantic, the Gulf of Mexico and the Mediterranean, using volunteer fishermen:
http://na.nefsc.noaa.gov/sharks

A number of outfitters, both non-profit and for-profit, lead cage-diving trips at South Africa's shark hotspots. These include African Shark Eco-Charters:
http://www.ultimate-animals.com; and Craig Ferreiro's White Shark Project expeditions, http://www.sharkbookings.com/white-shark-projects.html

Rodney Fox's Great White Shark Expeditions offers cage-diving trips to Spencer Gulf, South Australia. Unlike other shark cages which bob at the surface, these are lowered to the ocean floor:
http://www.rodneyfox.com.au

Lawrence Groth of Great White Adventures runs cage-diving trips to the Farallon Islands, off San Francisco, and the Isla Guadalupe, off the Baja Peninsula:
http://www.greatwhiteadventures.com/aboutus.html

Absolute Adventures operates shark-diving trips to Isla Guadalupe, the Bahamas and Roatan:
http://www.sharkdiver.com/packages.html

Among their wildlife and conservation tours and film training, Wildeye offers 'Bimini Shark Encounter', affiliated with the Bimini Biological Field Station:
http://www.wildeye.co.uk/sharks.html

Fiona's Shark Mania is an exuberant collection of links, news and illustrations by renowned shark artist Richard Ellis:
http://www.oceanstar.com/shark

African Odyssey offers shark-diving trips to the Protea Banks, on the Natal Coast south of Durban, South Africa. They use no cages and no chum, but prefer to attract bull sharks, tiger sharks, bronze whalers and occasionally whites with low-frequency sounds that simulate a fish in distress:

http://www.africanodyssea.co.za

Shark Diver Magazine, 'created by and for shark divers':
http://www.sharkdivermag.com

Sharkattacks.com features toothy photography and bumper sticker sales, but it also provides news reports of the latest encounters worldwide:
http://www.sharkattacks.com

Pelagic Shark Research Foundation in Santa Cruz, California, is an energetic organization sponsoring fieldwork and reporting the research of others, primarily focused on white sharks along the Central Coast of California:
http://www.pelagic.org

Located in Switzerland, the Shark Foundation's purpose is 'to contribute to the protection and preservation of sharks'. Their website features a running tally of sharks killed within the calendar year, approximately 100 million in 2006:
http://www.shark.ch

Monterey Bay Aquarium's shark education resources include shark-watching tips, eco-tourism, shark stories and art, and information on shark conservation. The aquarium has kept in captivity various young white sharks for as long as several months, at which point they're released into the wild:
http://www.mbayaq.org/efc/efc_smm/smm_resources.asp

Mote Marine Laboratory began in 1955 as a tiny research station operated by Dr Eugenie Clark with a grant from the Vanderbilt family. It now manages environmental research and education programmes and an aquarium that has hosted 400,000 visits:
http://www.mote.org

Ecocean offers an online Photo Identification Library, 'a visual data-base of whale shark encounters and of visually catalogued whale shark-s'. You can assist in their research by submitting your whale shark photos here: http://www.whaleshark.org

Wild Aid believes that, by working together, 'the governments and communities of the world can reverse the devastation of our planet's wildlife'. They're much concerned about the shark-fin trade: http://www.wildaid.org

Dedicated to shark study as well as shark conservation, the Shark Project is a non-profit organization founded in 2002 and headquartered in Dusseldorf, Germany: http://www.sharkproject.org/engl/html/team.htm

Operated by Alex ('the sharkman') Buttigieg, a professional diver from Malta with a passionate interest in sharks, Sharkman's World aims to 'save and protect sharks': http://www.sharkmans-world.org

This website belongs to Alessandro De Maddalena, President of the Italian Ichthyological Society, Curator of Italian Great White Shark Data Bank, member of the Mediterranean Shark Research Group, and shark illustrator. He's a very active scientist, and the links to articles are useful: http://www.geocities.com/demaddalena_a/demaddalena.html

The Shark Trust is the UK member for the European Elasmobranch Association. Their stated aim is to join forces with other groups concerned with shark, skate and ray conservation: http://www.sharktrust.org

The Discovery Channel has set up this handsome website featuring photographs and survivors' accounts from the sinking of the USS *Indianapolis* in 1945: http://www.discovery.com/exp/indianapolis/stories.html

The official website dedicated to the victims and survivors of the USS *Indianapolis*:
http://www.ussindianapolis.org/main.htm

Wolfgang Leander, a passionate free-diver and underwater photographer with a lifelong fascination in sharks, hosts an elegant website with his black and white photos and articles about sharks:
http://www.oceanicdreams.com

For those with a daily interest in sharks, Shark-L listserv, founded by Fiona Webster of Fiona's Shark Mania, is a marvellous resource, bringing together renowned scientists, serious amateurs, underwater photographers, writers and anyone else with a passionate interest in sharks. Those reluctant to receive a steady stream of emails may consult the Shark-L archives:
http://raven.utc.edu/cgi-bin/W.A.EXE?AO=SHARK-L

Acknowledgements

First and always I would like to thank Darra Goldstein, love of my life, best friend and first editor, for her tireless support and honesty. I would also like to thank Harry Gilonis for his witty and amiable aid with the images; Jonathan Burt for his astute editing; Jacob Weaver for his modern translations of Old German; Regina Quinn at the Clark Art Library and Wayne Hammond of the Chapin Library, Williams College, for their generous and expert assistance; Roland Merullo and Paul Russell for their encouragement and friendship; Ron Elliott for his patience with my questions; Scot Anderson for the tour of shark-infested waters; and Leila Crawford for her underwater companionship.

I gratefully acknowledge the research support of the Susan Turner Fund at Vassar College.

This book is dedicated to my two graces, Darra and Leila.

Photo Acknowledgements

The author and publishers wish to express their thanks to the below sources of illustrative material and/or permission to reproduce it.

Photo Kelvin Aitken/Peter Arnold, Inc. (www.peterarnold.com): p. 46 (right); photo Scott Anderson: p. 30; Archives Charmet/Bridgeman Art Library CHT 215943: p. 110; www.ardea.com: pp. 9 (photo Valerie Taylor), 45 (Douglas David Seifert); photo Peter Batson: p. 43 (right); photo Alexander Belensky/*The St Petersburg Times*: p. 24; photo Bridgeman Art Library Images: p. 135; British Museum, London: p. 53 [PD 1906-5-9-1 (6), photo Erich Lessing/Art Resource, NY, ART208044]; photos courtesy of Chapin Rare Book Library, Williams College, Williamstown, Massachusetts: p. 95; courtesy of the artists (Tzu Chen Chen, Eric Egron, Dora Matlz): p. 112; Cooper-Hewitt National Design Museum, New York: p. 122; photo Prudence Cuming, © the artist (Damien Hirst): p. 89; photo David Doubilet: p. 34; Stan Eales, courtesy cartoonstock.com: p. 101; photo Steve Forrest/Impact-Visual, for *The New York Times*: p. 90; courtesy of Haywood Corporation: p. 124; photos Paul Hilton: pp. 127, 128, 129, 130, 131; Kunsthalle Hamburg: p. 102 (Inv. 500 f/2, photo Elke Walford/Bildarchiv Preussischer Kulturbesitz/Art Resource, NY, ART300097); Library of Congress, Washington, DC (Prints and Photographs Division): pp. 67 (Work Projects Administration Poster Collection, LC-USZC2-5391), 106 (Office of War Information, Overseas Picture Division, Washington Division; LC-DIG-fsa-8b08001), 117 (LC-USZC62-83288), 118 (George Grantham Bain Collection, LC-DIG-ggbain-22426), 119, top (LC-USZC4-12314), 120 (LC-USZC62-64114); photo courtesy Mallett Cooper: p. 123 (top); Metropolitan Museum of Art,

New York: p. 73 (Catherine Lorillard Wolfe Collection, Wolfe Fund, 06.1234); National Gallery of Art, Washington, DC: p. 71 (Ferdinand Lammot Belin Fund, 1963.6.1); Natural History Museum, Edinburgh (MacGillivray Collection): p. 99; National Library of Australia: p. 76 (Rex Nan Kivell Collection; NK628/10); photo courtesy of Postmasters Gallery, New York: 142; courtesy John Pritchett: p. 103; photo Bruce Rasner/ Rotman: p. 46 (left); photos courtesy Rex Features: pp. 6 (Bob Shanley/ Rex Features, 327316E), 25 (Rex Features/South West News Service, 245879A), 27 (Rex Features/Greg Williams, 278595P), 57 (© Roger-Viollet/Rex Features, RV-474552), 96 (© Roger-Viollet/Rex Features (RV-369543), 97 (© Roger-Viollet/Rex Features (RVB-11667), 113 (Rex Features/Robert Judges, 445294AA); 114 (Rex Features/Mike Longhurst (677478AB); 119, foot (© LAPI/Roger-Viollet/Rex Features (LAP-13320A), 133 (Rex Features/Sipa Press, 225218E), 139 Rex Features/Sunset (535155A); photo Herb Ritts: p. 108; photos Jeff Rotman/Nature Picture Library (www.naturepl.com): pp. 11, 12, 20, 39 (left), 43 (left), 78, 116, 150; © Royal Asiatic Society, London/Bridgeman Art Library Images: 148 (foot), 149; © Royal Geographical Society, London/Bridgeman Art Library Images: 136; Schloss Ambras, Innsbruck, Austria: p. 111 (photo Erich Lessing/Art Resource, NY - ART190559); photo © Dan Schmitt/2007 iStock International Inc. (63009): p. 39 (right); photos SeaPics.com (www.seapics.com): pp. 15, 26, 37, 40, 125, 148 (top); photo John Steiner (Smithsonian Institution, Washington, DC): p. 29; Thomas Fisher Rare Book Library, University of Toronto: p. 93; photos Norbert Wu: pp. 22, 23, 32, 35, 42.

Index